Here's to
+ memories!
Stephanie Chauvin

IMAGES of America
ROCKY POINT PARK

Terry!
See you on the Midway!
DB

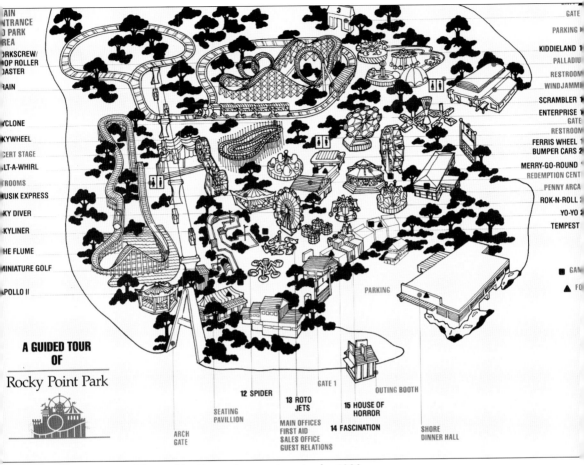

This is a map of the park's rides and attractions in the 1980s.

On the cover: In this photograph, patrons of Rocky Point stand along the midway sign in the mid-1930s. The sign was one of the few things that withstood the hurricane of 1938. (Courtesy of Anita Ferla.)

IMAGES of America
ROCKY POINT PARK

David Bettencourt and Stephanie Chauvin

ARCADIA
PUBLISHING

Copyright © 2009 by David Bettencourt and Stephanie Chauvin
ISBN 978-0-7385-6236-0

Published by Arcadia Publishing
Charleston SC, Chicago IL, Portsmouth NH, San Francisco CA

Printed in the United States of America

Library of Congress Control Number: 2008933810

For all general information contact Arcadia Publishing at:
Telephone 843-853-2070
Fax 843-853-0044
E-mail sales@arcadiapublishing.com
For customer service and orders:
Toll-Free 1-888-313-2665

Visit us on the Internet at www.arcadiapublishing.com

To my three boys, who have come to love a place they've only heard and read about.
—*David*

To my father, who always spelled it backward but couldn't trick me. I knew we were going to Rocky Point.
—*Stephanie*

Contents

Acknowledgments 6

Introduction 7

1. Early Years 9
2. Food and Fun 47
3. Rides and Attractions 63
4. Ruins and Demolition 113

Acknowledgments

This book, along with the documentary, could not have been possible without the generous help of so many families and friends. We have met so many people who felt the same love and adoration for this amusement park as we do, and it has been a blast listening to stories, looking at photographs, and laughing along with all of you. Unless otherwise noted, all images in this book have come from the personal collection used in the making of the documentary *You Must Be This Tall: The Story of Rocky Point Park*.

A sincere thank-you to Anita Ferla, who shared her personal collection with us and sat and told us beautiful stories of her late great husband, Conrad.

A warm thank-you to John Caruthers, who is one of the kindest souls you will have the pleasure of meeting. His knowledge and collection of images are astounding, and he is one of our favorite people to have breakfast with.

Thanks to John and Cheryl Gould, who shared wonderful stories and photographs with us.

Special thanks to Walter Sullivan, Rick Harris, Dorothy Smith, Wade Crawley, Theresa Bucci, Ronald Guarnieri, George LaCross, Jeffrey Paradysz, Walter Bailey, and Alan Ramsay.

A very special thanks to Nicole Gesmondi, a talented young photographer who accompanied us on our many trips through the abandoned Rocky Point. We wish her the best of luck.

Most of the research was done at the Warwick Historical Society. Special thanks to everyone there, especially Felicia Gardella and Henry Brown.

And finally, a hearty thank-you to all the families who shared their stories with us, to all the former park employees who gave us insight on the park, and to all the people who made Rocky Point Park a place for us to cherish forever.

It may be gone, but it is certainly not forgotten.

INTRODUCTION

Picture the days of driving down Rocky Point Avenue. Anticipation hung heavy in the air, mixing with the inviting smell of clam cakes, hot and crisp. The first glimpse of the front gate caused a leap in the pit of our stomachs. We knew we were about to experience one of the highlights of a new summer season. We knew it was a tradition. We did not know it would end.

No matter how long ago we made our first trip to Rocky Point Park, we had been preceded by so many generations of those who sought entertainment, relaxation, and fun. In the 1800s, there were steamboat travelers and Sunday school children landing on its shores. Soon after, there were resort vacationers, many from as far away as the Carolinas, rubbing elbows with beach-bound Rhode Islanders. The 20th century brought dancers and diners and, as time wore on, thrill seekers and concertgoers. But what remained a constant, as the point evolved from picnic ground to full-fledged amusement park, were the families.

The legacy of Rocky Point as a family park is what inspired us to include so many personal family photographs in this book. We drew from their experiences in order to create a more accurate memory of what the park really meant to southern New Englanders. The strong connection between families and the park started to become apparent as we embarked on the research phase of the documentary *You Must Be This Tall: The Story of Rocky Point Park*. While interviewing various people whose lives had been touched by the park, families began to share both their warm recollections and candid photographs of the park. We heard about love stories, mishaps, rumors, and forgotten history. There was a realization that Rocky Point Park was not just a destination, but for many of us, in a way, it was our own backyard. Out of this realization was born a desire to bring these photographs and stories into one collection to be shared.

For those of us who remember the park, this book is a trip back to summers past. It is an opportunity to wax sentimental and bask in a nostalgic glow. But perhaps more importantly, it is a means by which to preserve and pass on an important part of Rhode Island tradition to a generation who will never feel the splash of the flume or marvel at the view from the Skyliner.

Most of us, of course, will not recall the very early history of the park. Two hurricanes, fires, a multitude of owners, renovations, and additions made the park of the 20th century almost indistinguishable from the resort of the 1800s. Still there was the same beautiful shoreline (not too much worse for the wear) and the incomparable Shore Dinner Hall, which remained a staple throughout the operation of the park and even a short time beyond. The historic photographs included in the book offer those of us who have always felt a kindred familiarity with the park a peak at a Rocky Point Park to which we are less accustomed. Some of the rides seem primitive, while others are shockingly ahead of their time. All were enjoyed for prices that seem unimaginable!

Despite its rich history and seemingly everlasting resilience in overcoming adversity, the park fell victim to poor management and diminishing patronage in the mid-1990s. It was a heavy blow to the community when the park finally closed its gates after the summer of 1995, thus ending a long chapter in Rhode Island history. The 89-acre parcel of land that was once the site of bonfires, clambakes, amusement, and celebration is now desolate and vandalized. The last chapter of the book reveals a portrait of Rocky Point Park that few have seen. It is a graveyard of memories, haunted by the echo of a time gone by and enlivened only by the resurrection of auctioned rides that now operate in various other amusement parks.

In 1847, when Capt. William Winslow purchased Rocky Point, he had a vision of what the park would be. He saw its potential for steamboat access as well as its prime position on the bay, which provided for beautiful scenery and gentle breezes. He knew its attraction would be unparalleled by any other Rhode Island resort. One pauses to ponder, however, if he realized the longevity his newly acquired park would have. Not only did Rocky Point live on as New England's playground for almost a century and a half, it will also continue to live on in the hearts and minds of those who played there. We hope this book will help to propagate fond memories of Rocky Point.

One
EARLY YEARS

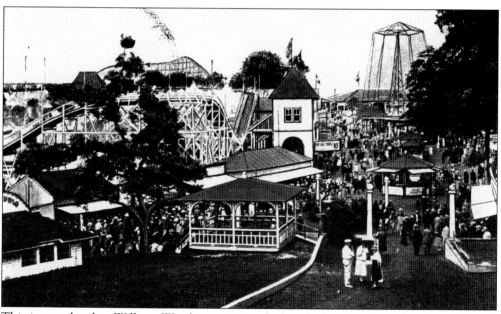

This is exactly what William Winslow envisioned when he bought the park: a beautiful and romantic spot along the bay, filled with roller coasters, swings, rides, and attractions.

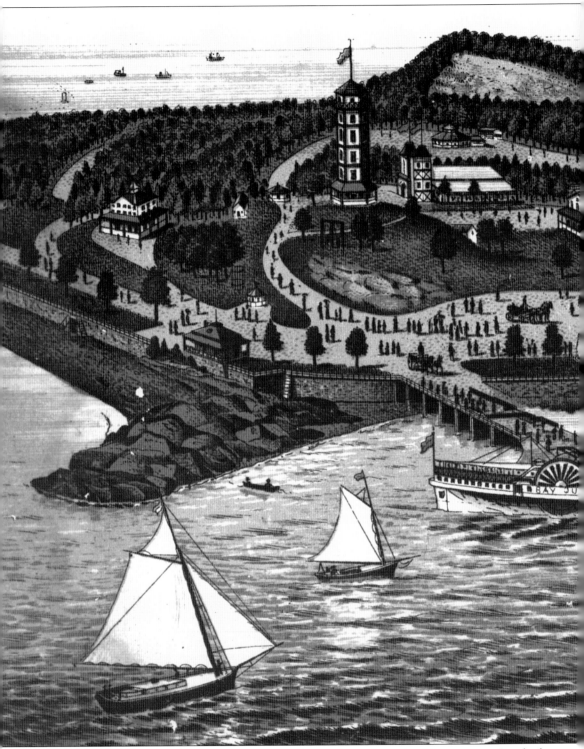

By the mid-1800s, steamboat excursions to various points along the Narragansett Bay had become a popular summer pastime. Capt. William Winslow, part owner of a small steamboat the

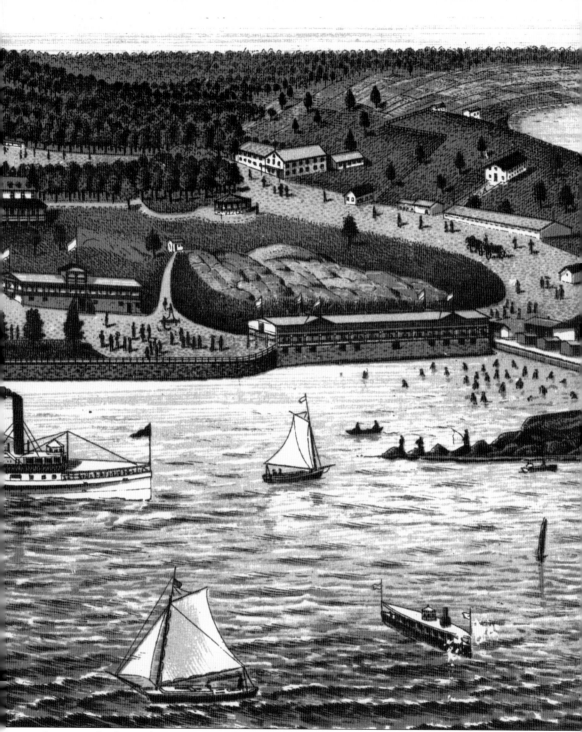

Argo, was the first to begin using Rocky Point as his destination. Having received permission to use the shorefront property, Winslow landed with the 520 guests of a Sunday school picnic.

Capt. William Winslow's outings to Rocky Point were such a success that he saw the potential for a more permanent resort destination. He purchased the 89-acre parcel of land in 1847 from the Stafford daughters, Phoebe Lyons and Mary Holden, for around $2,400.

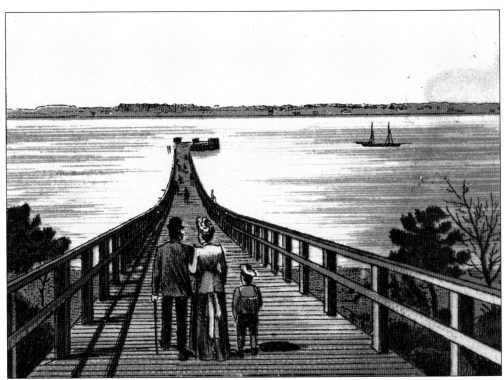

As a means to generate revenue, Captain Winslow built a dock where excursion boats could land for a fee of 25¢.

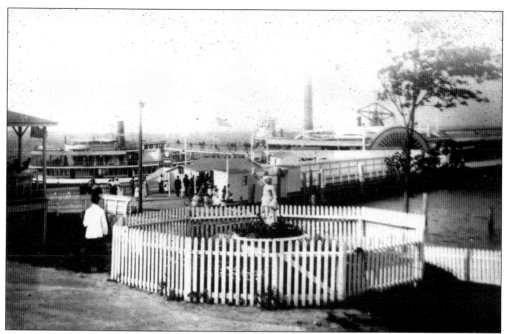

The picket fences at Rocky Point were often used to retain the mounds of clamshells from the frequent New England clambakes. They also served another purpose. In the mid-1800s, there was a casino operating near Rocky Point Park. Captain Winslow, who intended the park to be used primarily for church picnics, had the fences installed as a means of keeping any wandering gamblers off the park grounds.

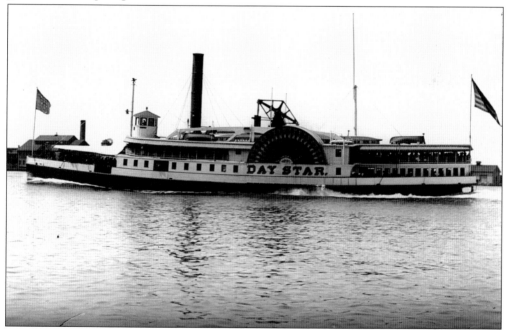

In 1873, the American Steamboat Company added the *Daystar* to its fleet that landed at Rocky Point. American Steamboat Company was just one of the steamboat companies that held an interest in the resort in the late 19th century.

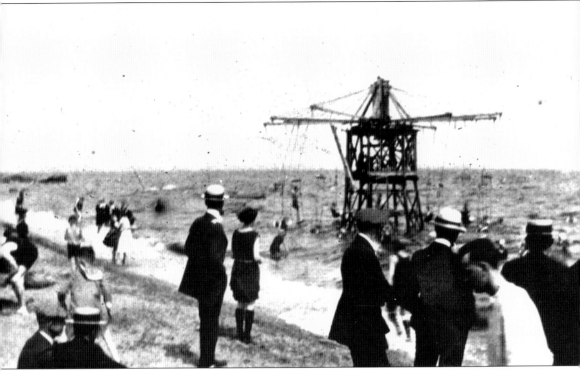

Attractions such as the Sea Swing helped make "Winslow's Rocky Point" the most popular spot on the Narragansett Bay by 1852.

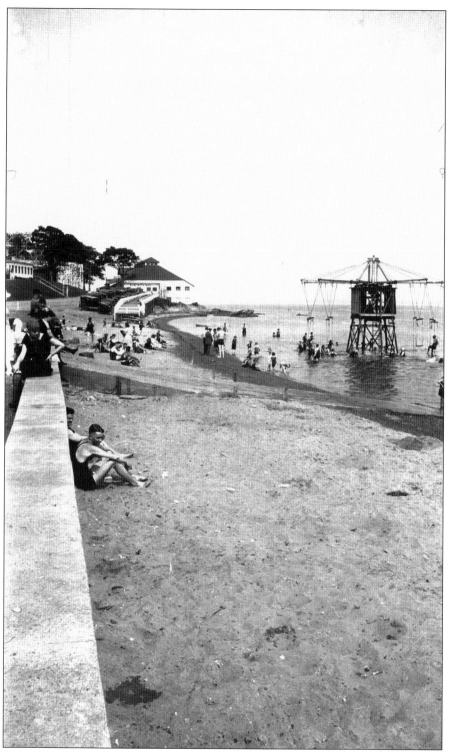
The Rocky Point Beach drew so many tourists from the southern New England area that in 1920 park owners spent $50,000 on a bathing pavilion.

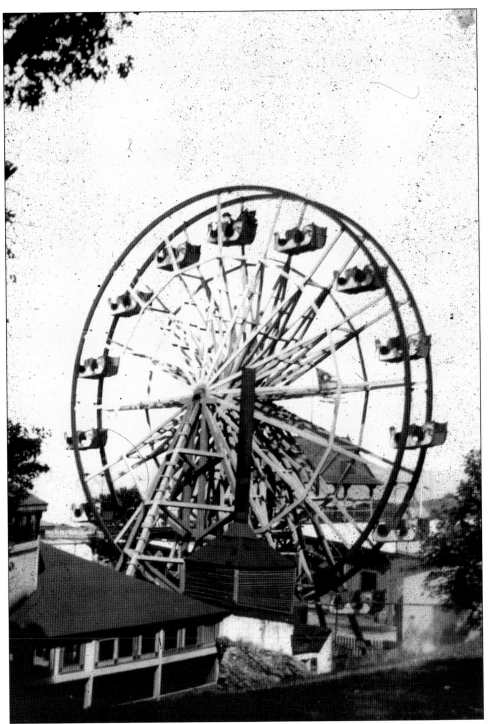
Since the 1850s, fandango wheels of different sizes were entertaining guests at Rocky Point Park. This 60-foot wooden creation was the work of Charles Looff, one of the world's most famous builders of carousels. It had 16 cars that each held two passengers during their slow, revolving view of the bay.

BILL OF FARE

ROCKY POINT, SEPTEMBER 2, 1859.

Baked Clams.

Baked Potatoes.

Baked Sweet Corn.

Baked Fish.

Fish Chowder.

Brown Bread.

DINNER TICKETS 40 CENTS!

Can be procured on the Train.

To avoid confusion, and in order to ensure ample arrangements, it is hoped that all who intend to partake of the Bake, will procure their Tickets of the person on the cars.

This bill of fare advertises the shore dinner in 1859. A busy time for the Shore Dinner Hall during this era was Scotch Day. Posters advertising this event were plastered on the windows of shops throughout Providence, boldly proclaiming, "Dinner Ye Hear It!"

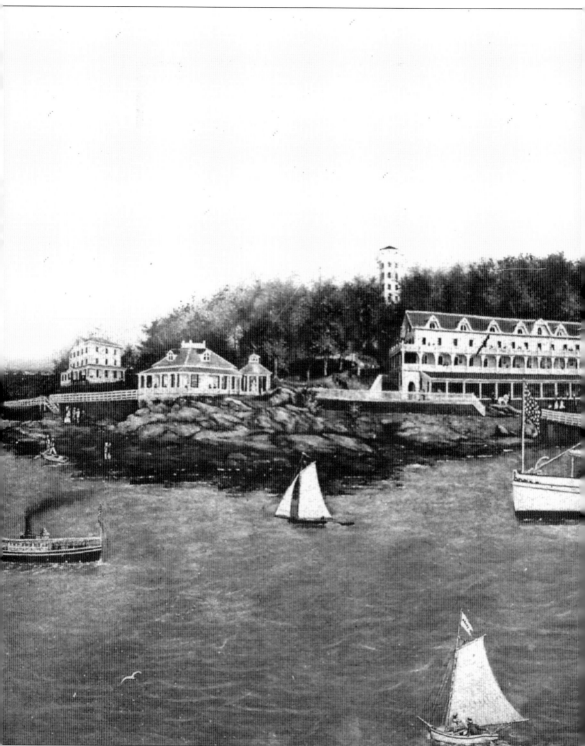

In 1875, the demand for transportation to the Rocky Point resort was so high that the American Steamboat Company added yet another boat to the run. The *Crystal Wave* had the advantage

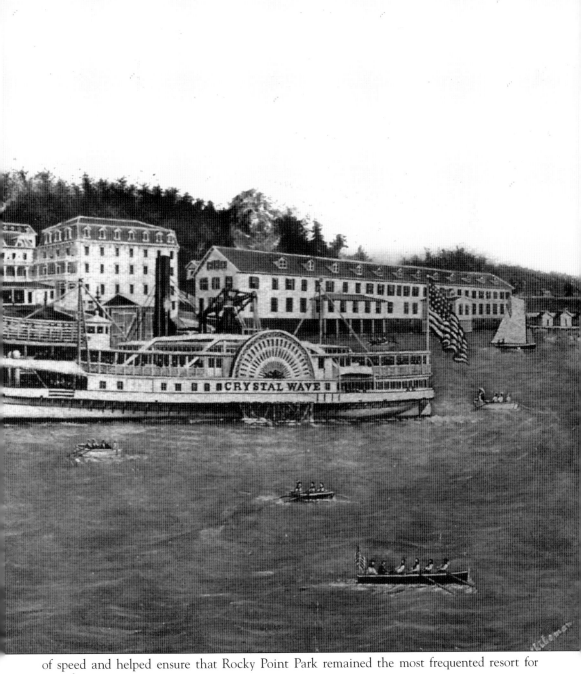
of speed and helped ensure that Rocky Point Park remained the most frequented resort for steamboat passengers.

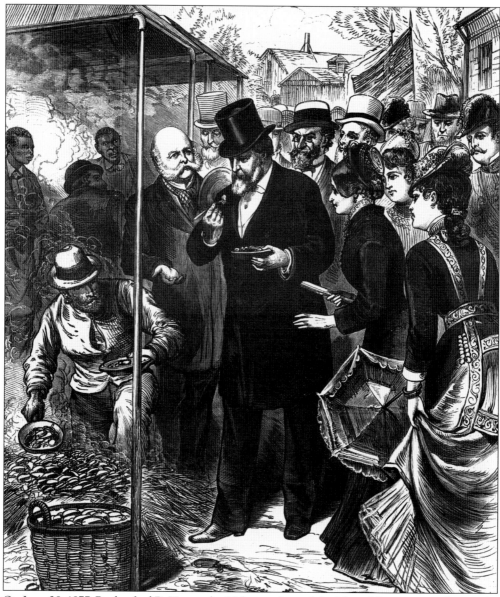

On June 28, 1877, Rutherford B. Hayes, the 19th president of the United States, arrived at Rocky Point Park's mansion house where he was met by Gov. Charles Van Zandt. President Hayes spoke to a large crowd honoring Civil War veterans, ate clams and chowder at a traditional clambake, and made the first presidential telephone call. The call, between Hayes and Alexander Graham Bell, who was in Providence at the time, lasted only a brief moment. The first words spoken by a president into a telephone? "I'll need you to speak a little more slowly." (Courtesy of Rutherford B. Hayes Presidential Center.)

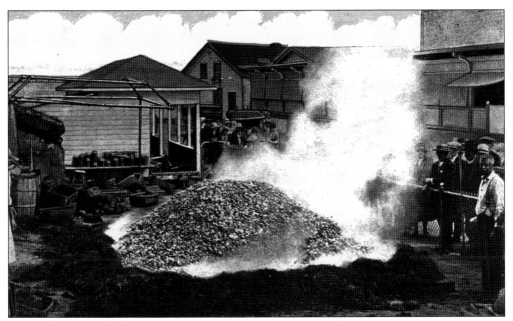

Around 1900, Rocky Point's clambakes were overseen by Jerry, the "famous Indian Chowder and Fish Cook," who was considered an expert on the original Rhode Island clambake.

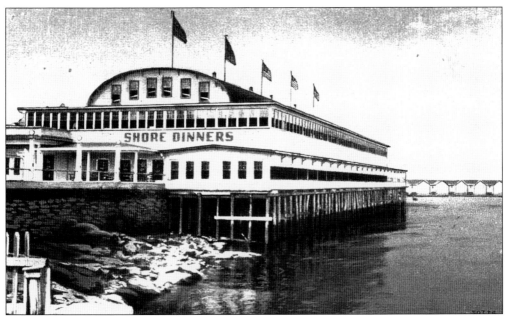

In 1880, a shore dinner in this majestic hall included clam chowder, baked clams, two kinds of baked fish, white and brown bread, corn on the cob, tomatoes, and watermelon, and cost 50¢. For an additional 25¢, one could add a lobster.

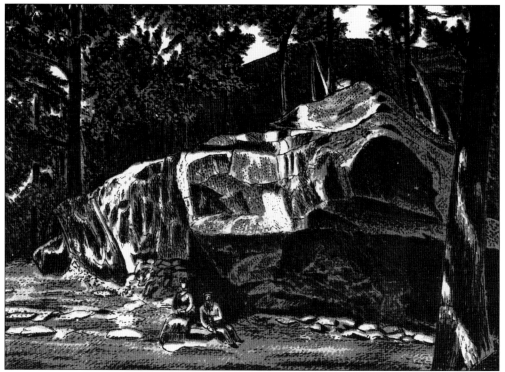
Visitors to the park in the 1850s would walk up to this area, called the "Caves." It was a collection of large boulders and rocks that formed small caves and odd underground passages.

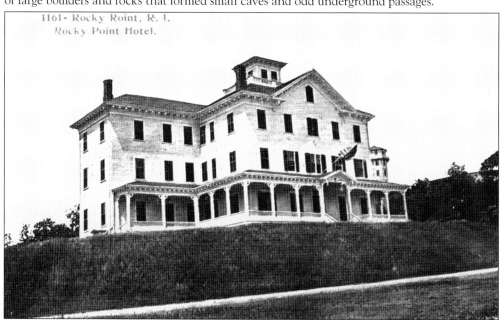
In the 1860s, Byron Sprague purchased Rocky Point from Capt. William Winslow for $6,000. He spent nearly $300,000 on developing the area into a beautiful and romantic resort. This included the addition of a hotel that accommodated up to 300 guests. On March 16, 1883, however, a fire broke out, destroying the hotel, along with a dining hall and boathouse.

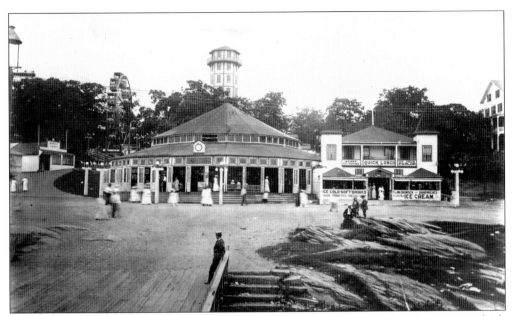
Among the many improvements that Sprague made to Rocky Point was this observatory, which allowed guests panoramic views of the area, including Narragansett Bay. It was over 250 feet tall, and each of its eight sides had a window on every floor.

Postcards were a popular way to keep in touch with loved ones back at home.

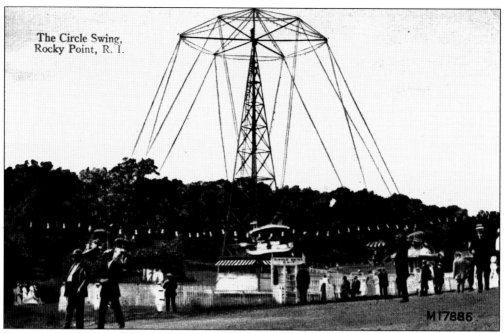

One of the earliest and most popular rides at Rocky Point Park, the circle swing was a mainstay at amusement parks in the 19th century.

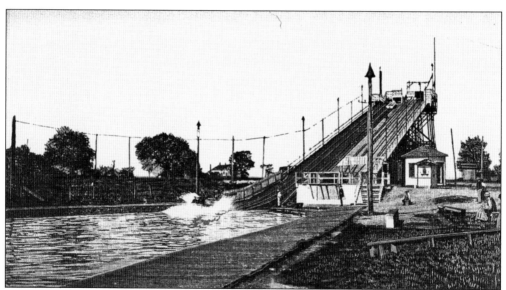

New for the 1892 season, the Big Tobaggan joined two theaters, free vaudeville, live bands, an orchestra, and free dancing as the main attractions at Rocky Point.

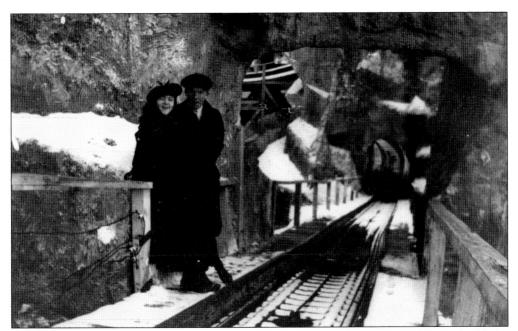

Rocky Point Park hired roller coaster designer LaMarcus A. Thompson in 1911 to build the Mountain Scenic Railway. It was a long, relatively slow coaster ride through dark tunnels and artistic mountain scenes.

On the Fourth of July, people from all over the area would come to Rocky Point Park for dancing, live music, bonfires, and fireworks.

The invention of automobile mass production in 1914 had a serious effect on trolley parks across the United States, as owning an automobile became more and more affordable to families, and trolley lines started to disappear. Rocky Point Park, however, continued to flourish.

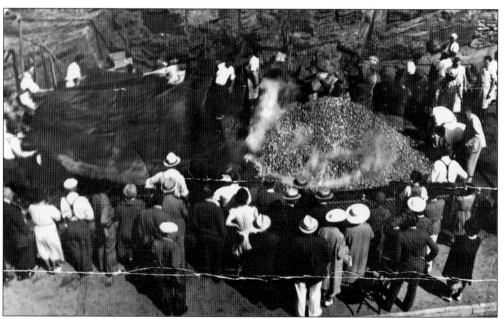

The traditional New England clambake at Rocky Point would draw hundreds of hungry visitors.

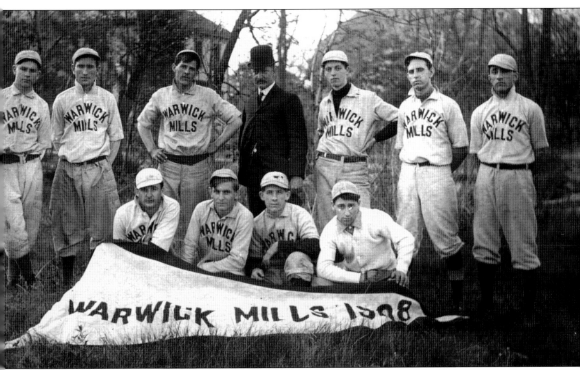

Col. Randall A. Harrington, who bought Rocky Point Park from a steamboat company in 1910, made a number of improvements to the ball field, which helped to bring in major-league exhibition games. Harrington also allowed for Sunday baseball to be played at Rocky Point Park, something most people found quite immoral at the time but Harrington found to be quite lucrative. (Courtesy of Rick Harris.)

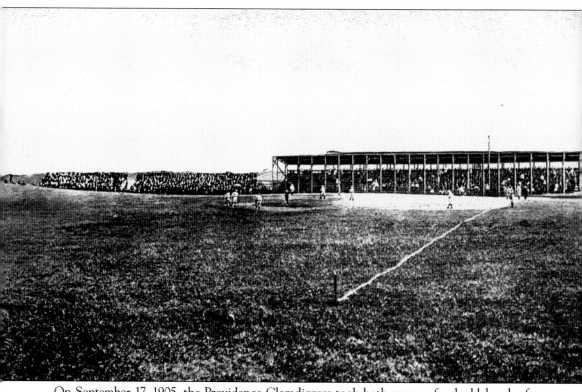

On September 17, 1905, the Providence Clamdiggers took both games of a doubleheader from the Toronto Maple Leafs, 12-2 and 12-4. The games drew the largest crowd ever recorded at Rocky Point Park, 14,060. Later in 1914, the Providence Clamdiggers would play an exhibition game at Rocky Point Park against hall of famer Tris Speaker and the Boston Red Sox. (Courtesy of Rick Harris.)

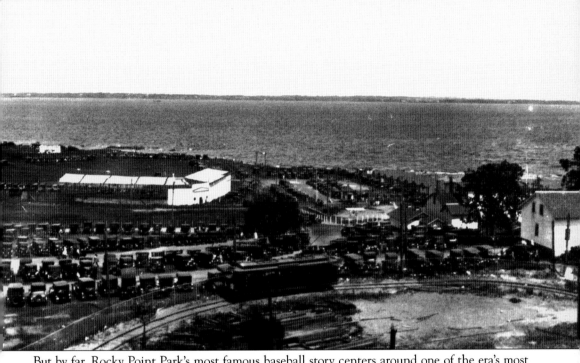

But by far, Rocky Point Park's most famous baseball story centers around one of the era's most popular athletes. George Herman "Babe" Ruth, pitching for the Providence Grays, hit a ball out of the field of play and into the water for what appeared to be a home run. But Rocky Point Park had a ground rule, lose a ball into the water, it was a ground rule triple. The legend is a home run, but the box score said something quite different. What cannot be disputed is the fact that during the spring of 1914, thousands of baseball fans flocked to Rocky Point Park's ball field each and every Sunday in order to catch a glimpse of their favorite southpaw.

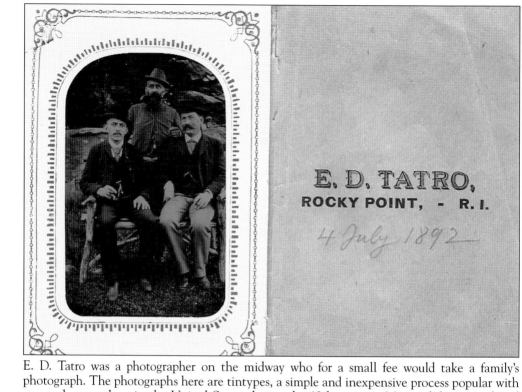

E. D. Tatro was a photographer on the midway who for a small fee would take a family's photograph. The photographs here are tintypes, a simple and inexpensive process popular with street photographers in the United States during the 19th century. Many of the poses found in these photographs were casual, often staged either in the studio or out near the caves and rock formations.

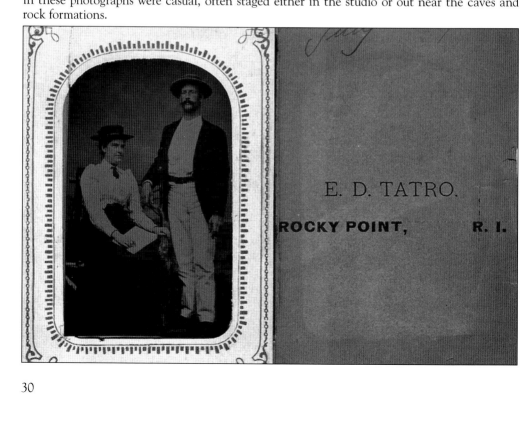

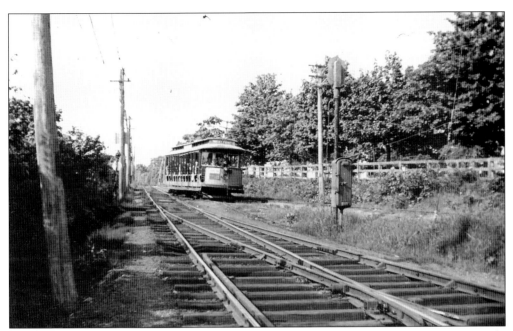

The Warwick Railroad electrified its rails and installed a trolley loop at Rocky Point Park, allowing for a shorter walk from the rail station to the park itself. Trolleys left every five minutes from Providence for Rocky Point Junction. These open cars were part of the Rocky Point Park experience and would take thousands of visitors to the park daily.

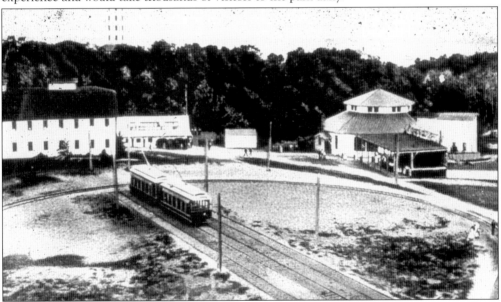

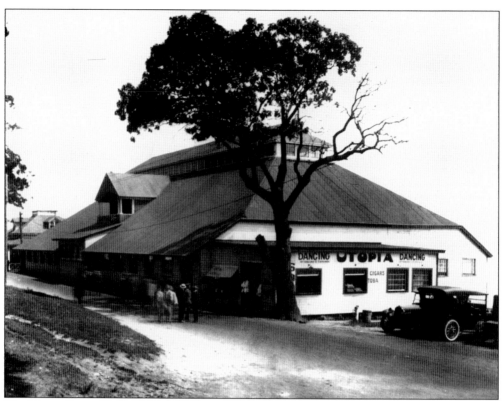

The Utopia Dance Hall underwent a change of management in the spring of 1920. Under this new leadership, a large orchestra was hired to provide more fashionable music than in past years.

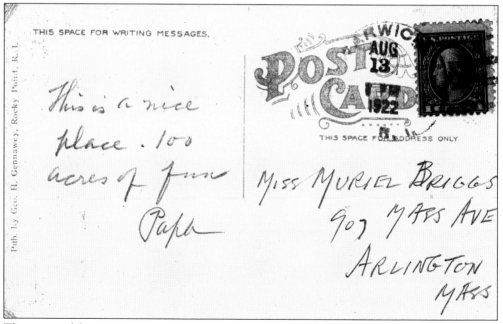

This postcard from August 1922 says it all: "100 acres of fun."

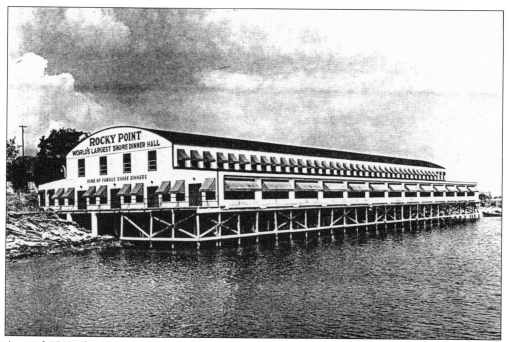

Around 1910, the Shore Dinner Hall served well over 100 bushels of clams per day. In order to accommodate the growing demand for shore dinners, the massive hall was expanded to seat 2,500 guests.

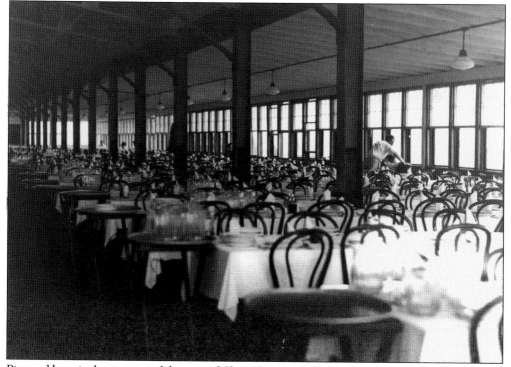

Pictured here is the interior of the second Shore Dinner Hall. The first dining hall was destroyed in the great fire of 1883.

OUTING

St. Vincent De Paul Society,
Fall River

ROCKY POINT

TUESDAY, AUGUST 3, 1920.

Good for one Ride on Witching Waves

AUGUST 3, 1920.

6C INCLUDING WAR TAX

Good for one Ride on Scenic Railway

AUGUST 3, 1920.

6C INCLUDING WAR TAX

Good for one Ride on Roller Coaster

AUGUST 3, 1920

6C INCLUDING WAR TAX

Good for one Ride on Midway Carousell

AUGUST 3, 1920.

6C INCLUDING WAR TAX

Good for one Ride on Whip

AUGUST 3, 1920.

6C INCLUDING WAR TAX

Good for one Ride on Circle Swing

AUGUST 3, 1920.

6C INCLUDING WAR TAX

Many companies and organizations held their annual outings at Rocky Point Park. Perhaps the most interesting outing occurred on August 4, 1892, when the entire Fall River Police Department went on its annual Rocky Point Park picnic. While the police were enjoying their time in Warwick, Lizzie Borden allegedly murdered her father and stepmother in one of the most celebrated court cases of the late 19th century. (Courtesy of the Warwick Historical Society.)

Nobody's photo album was complete without a picture with Leo, the cast-iron statue of a lion that stood at Rocky Point Park for over 60 years. There was often controversy surrounding the statue, with some guests claiming there were once two lions and others taking the position that there had only ever been one. Perhaps the confusion began when the lion was moved from the park's entrance to a spot by the beach. (Courtesy of the Warwick Historical Society.)

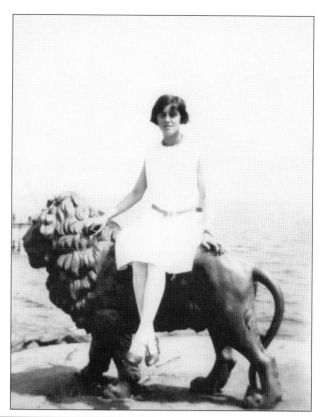

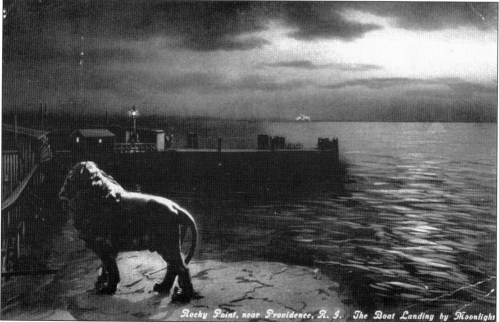

In September 1944, Leo the lion was found smashed and beheaded by vandals. Many felt at the time that Rocky Point Park just was not the same without its beloved Leo. The vandals were never caught, and the head was never found.

SAYLES FINISHING PLANTS - PLANT A

Sayles' Bleacheries

Saylesville, R.I. July 6, 1920

Rocky Point Amusement Co.,
 Warwick Neck, R.I.

IN REPLYING TO THIS LETTER
PLEASE REFER TO FILE Pur Dept.

SUBJECT:
Attention Mr. Morse

Gentlemen:

As per our conversation regarding the concessions, I am sending you a copy of this Agreement covering our Annual Outing on Wednesday July 21st.

```
Theater            ----------------------10¢
Hammer             ---------------------- 3¢
Bagley Bros        ---------------------- 8¢
Scenic Railway     ---------------------- 6¢ and 8¢
RollerCoaster      ---------------------- 6¢
2 Merry-go-rounds  ---------------------- 6¢
Whip               ---------------------- 6¢ and 8¢
Bewitching waves   ---------------------- 6¢ and 8¢
Worlds Museum      ---------------------- 6¢
Circle Swing       ---------------------- 6¢ and 8¢
Areoplane          ---------------------- 6¢ and 8¢
Ten and one Show   ---------------------- 6¢ and 8¢
Alligator Farm     ---------------------- 6¢ and 8¢
Dancing for Afternoon ----------- 2½¢ for each Dance
   5¢ admission with S F B Button allowing for pass
   out in afternoon.
Dancing for evening ---------------- 15¢ admission
Bathing            ----------------------25¢
Dinner             ----------------------1.75
```

Committee Room, Hospital and Ball Field - free.

S.F. Plants Button to be used and recognized for one half rate fee on all of the above concessions.

Yours truly,

Chairman Grounds Committee.

F H Cushman

In a correspondence letter from 1920, the Sayles Finishing Plant discusses prices of rides and entertainment for its upcoming outing at Rocky Point Park. (Courtesy of the Warwick Historical Society.)

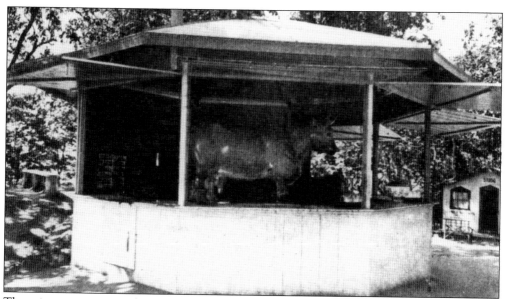

There is a great rumor about this statue of a cow. Allegedly, during Prohibition, rumrunners would smuggle booze into Rocky Point Park. The cow would be used to contain the illegal alcohol, which would then be dispensed to those who chose to indulge through the udders, which served as a tap. (Courtesy of the Warwick Historical Society.)

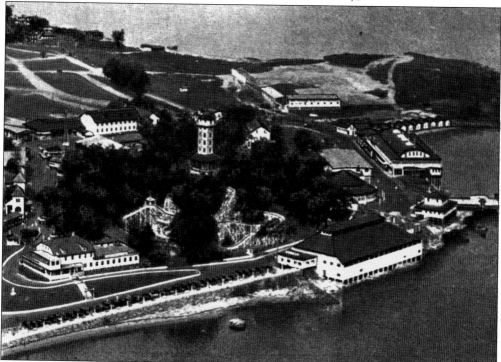

A new bathing beach and pavilion was added to the park in 1920. Among the new accommodations was $15,000 in new bathing suits, described in a letter from the owners as "the latest models . . . and in all the most beautiful colors that are in use in the most fashionable resorts throughout the country."

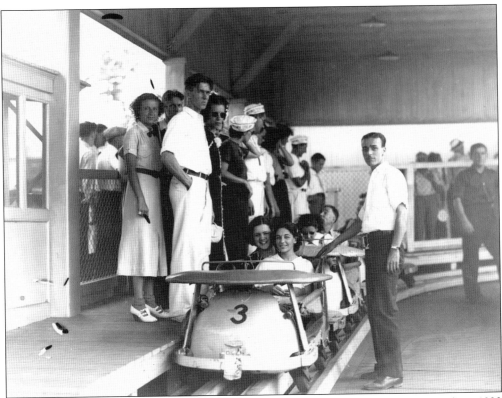

Herbert Schmeck designed over 80 coasters for the Philadelphia Tobaggan Company from 1923 to 1955. The Flying Turns, a bobsled coaster, was one of Schmeck's more popular designs.

The Flying Turns was installed at Rocky Point Park in 1931 and ran until it was destroyed by the hurricane of 1938. At the time this picture was taken, a ride on the Flying Turns cost 10¢.

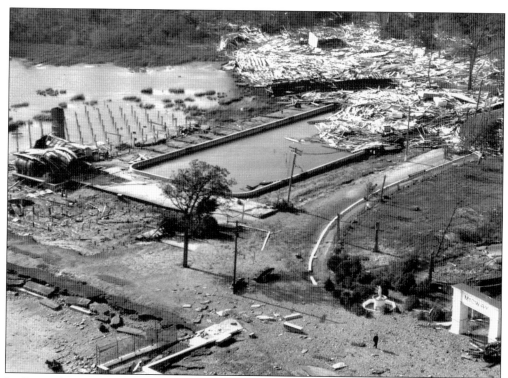

In September 1938, a fierce hurricane hit New England, causing an unbelievable amount of damage throughout the area. Due to its location along the shallow waters of Narragansett Bay, Rocky Point Park was devastated. The Shore Dinner Hall was completely swept away, and the midway was reduced to splinters. The park did not reopen until 1940 but did not really recover from the losses caused by the storm until its rebirth in 1947.

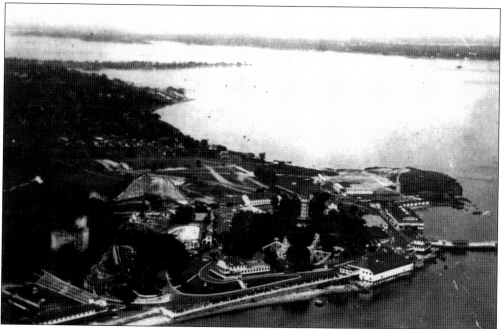

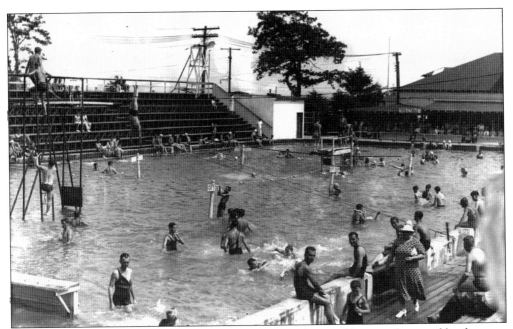

This is Rocky Point Park's famous saltwater pool. It was damaged but not destroyed by the great hurricane of 1938. Although the pool withstood the hurricane, the park's business did not. The extensive destruction caused by the storm, combined with the economic troubles brought on by World War II, caused the park to close its gates. Rocky Point Park would remain closed for nearly 10 years until being revived by the efforts of the Ferla family.

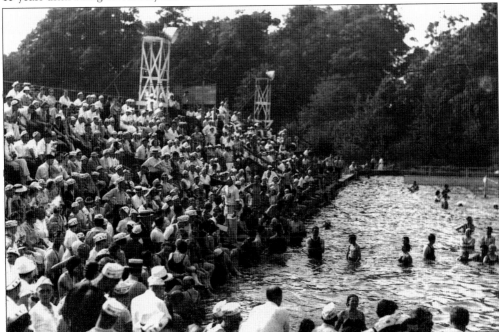

Bathers enjoy New England's largest saltwater swimming pool, which had numerous diving boards, a bathing pavilion, and a bathhouse. Pumps brought filtered salt water from the ocean into the pool.

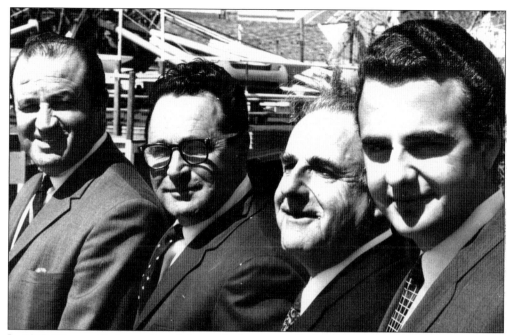

In 1947, Vincent Ferla purchased the park along with Frederick Hilton and Joseph Trillo. This picture of the Ferla brothers was taken in 1967. Seen here are, from left to right, Conrad, John, and Vincent and his son Vincent. (Courtesy of Anita Ferla.)

Conrad became general manager in 1949 and quickly earned himself the nickname "Mr. Rocky Point Park" for his hard work and dedication. (Courtesy of Anita Ferla.)

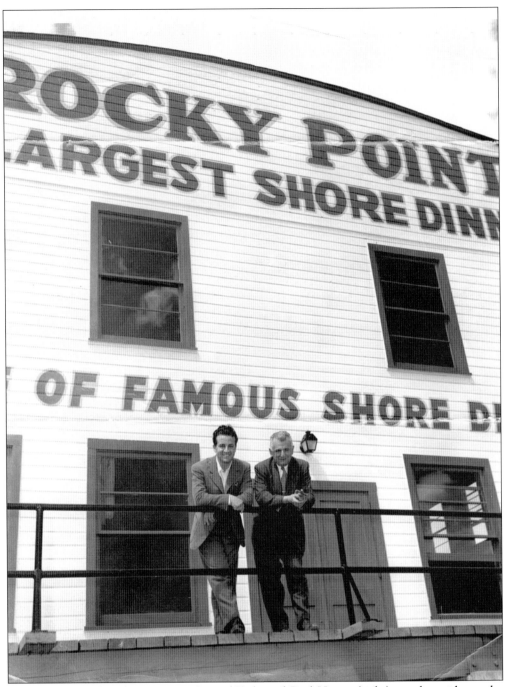
In this photograph, taken in 1949, Conrad Ferla and Paul Haney (right) stand outside on the deck of the Shore Dinner Hall. At the time, Haney was the general manager of the hall. On August 31, 1954, Hurricane Carol would wash away this building, forcing ownership to build a more modern Shore Dinner Hall across the street. (Courtesy of Anita Ferla.)

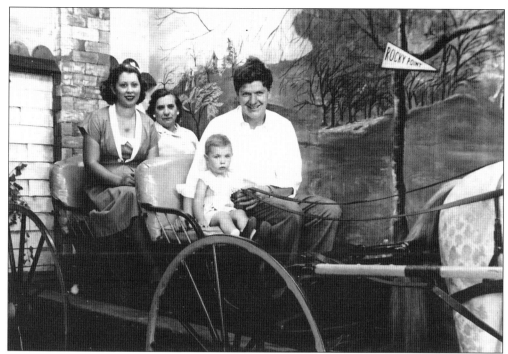

Families often posed and had their photographs taken at the photograph shop along the midway. Here is the young Ferry family from Johnston: Donald and little Leslie in the front, and Dolores and Aunt Jenny Nardi in the back.

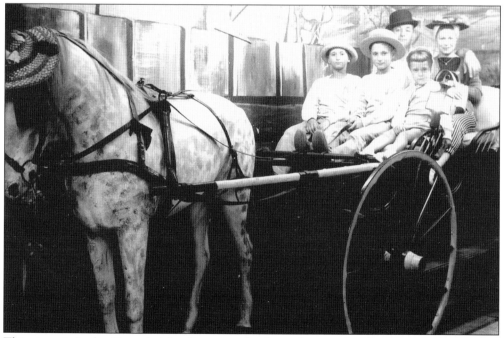

This time, it is the Guarnieri family posing for their photograph. The photograph shop had other backgrounds, including the "Honeymoon Cottage," the "Rocky Point Bar," and the "Rocky Point Jail." (Courtesy of Ronald Guarnieri.)

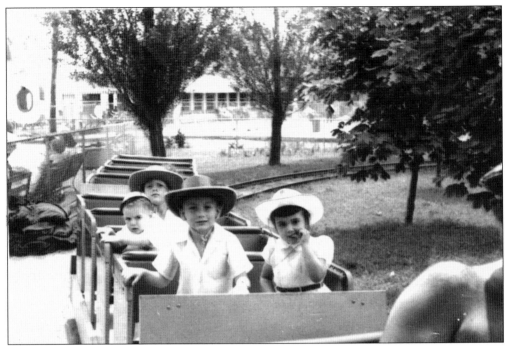

Aboard the Rocky Point Express in July 1955 are Frank and Jack Martone with their cousins Diana and Frank Chauvette. The swimming pool is in the background. (Courtesy of Frank Martone.)

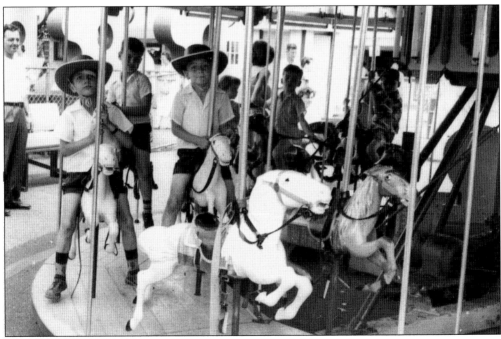

This Kiddie Carousel is seen in 1955. (Courtesy of Frank Martone.)

David DiCenso enjoys a ride in Kiddie Land in June 1954. (Courtesy of David DiCenso.)

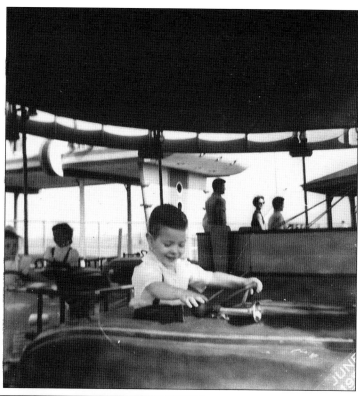

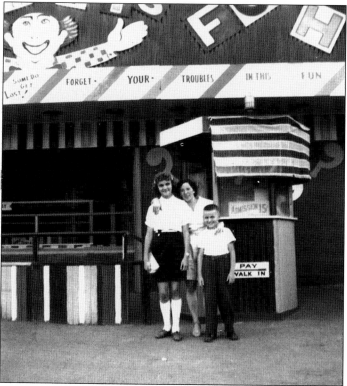

This photograph was taken outside the fun house, where people could forget their troubles for 15¢. Be warned, however, some people did get lost. (Courtesy of Wade Crawley.)

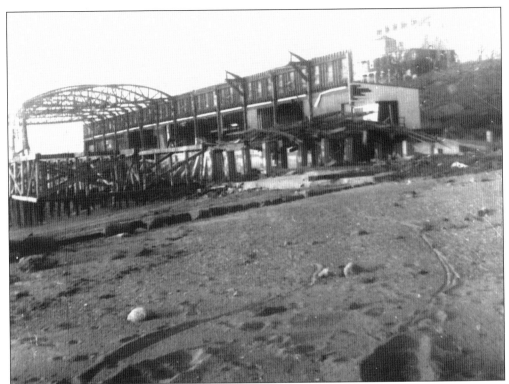

On August 31, 1954, Hurricane Carol struck New England and again washed away the Shore Dinner Hall. The Ferris wheel is bent in half, and the midway is nearly completely destroyed. (Courtesy of Anita Ferla.)

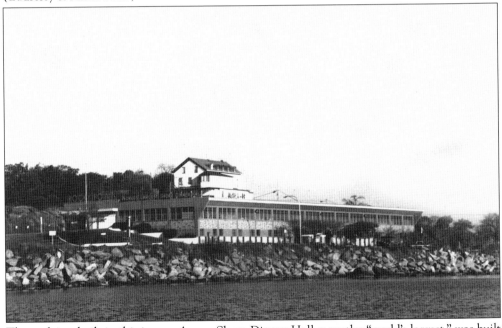

The park is rebuilt in this image. A new Shore Dinner Hall, now the "world's largest," was built more inland and could accommodate close to 4,000 guests. (Courtesy of Anita Ferla.)

Two
Food and Fun

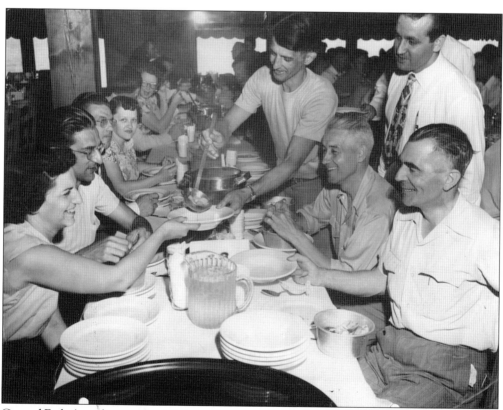

Conrad Ferla (standing, to the right) watches as employees from the Fall River Luggage Company enjoy all-you-can-eat clam cakes and chowder in the Shore Dinner Hall. Large companies often had their outings at the park. (Courtesy of Anita Ferla.)

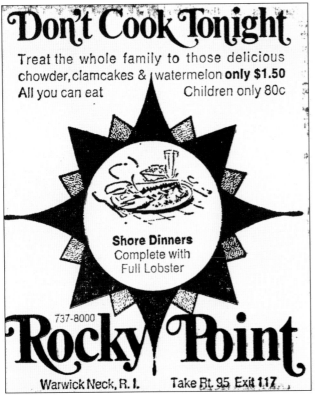

Why would people cook for their family when they could get all-you-can-eat clam cakes, chowder, and watermelon for just a buck and a half? And children were even less than that.

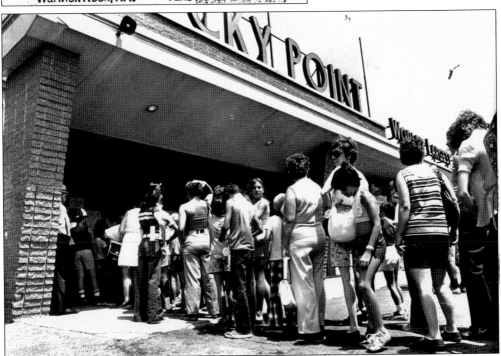

On July 4, 1976, close to 38,000 people were served in the world's largest Shore Dinner Hall at Rocky Point Park.

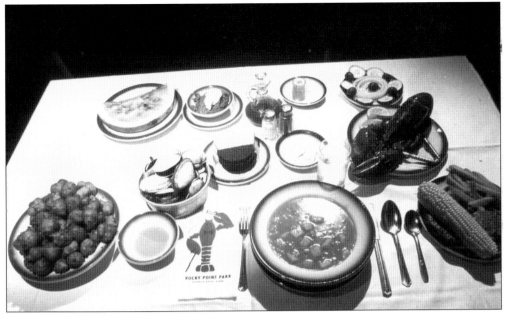

The typical shore dinner was famous Rocky Point clam cakes and chowder accompanied with Bermuda onions, queen olives, cucumbers, white and brown bread, steamed clams, baked fish, french fries, corn on the cob, boiled lobster, and Indian pudding.

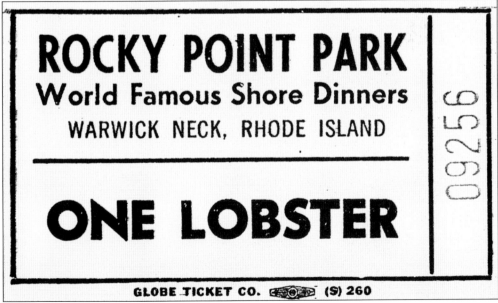

While the all-you-can-eat, family-style dinners were served at long tables in the middle of the hall, separate lobster dinners were often served along the windows overlooking Narragansett Bay.

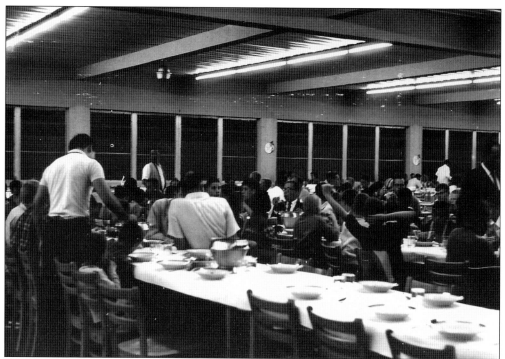

It was once estimated that the Shore Dinner Hall served over 500,000 gallons of clam chowder, 9,000 pounds of lobsters, and used over 10,000 pounds of minced clams a year.

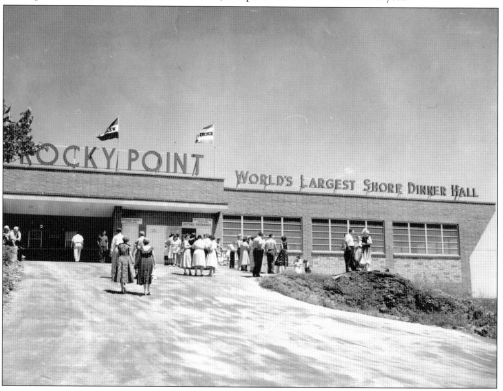

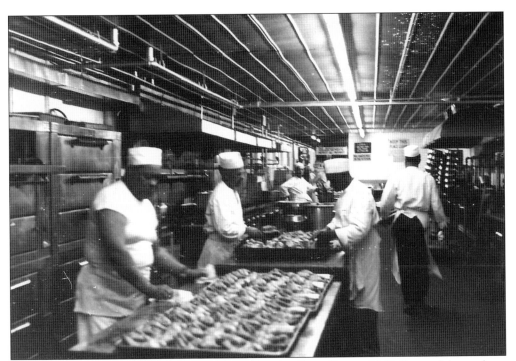

In the kitchen, the cooks prepare for the crowds at the Shore Dinner Hall. Some of the cooks at Rocky Point Park lived and worked at the park. (Courtesy of Anita Ferla.)

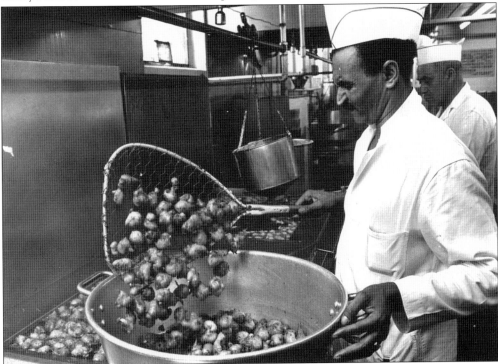

A New England tradition, clam cakes have been served at seaside diners and clam shacks for generations. Here they are scooped out of the fryer to be served.

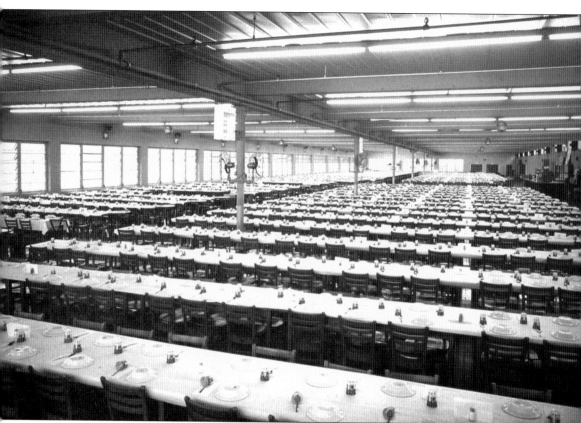

Rows and rows of tables, each covered with the signature white paper, filled the hall for a truly unique dining experience. Those who prized the food more than the experience did not always have to travel to Rocky Point to enjoy its famous fare. In the 1990s, there were off-site concessions, which sold official Rocky Point clam cakes and chowder. Locations included Post Road, in Warwick, as well as the Rhode Island Mall.

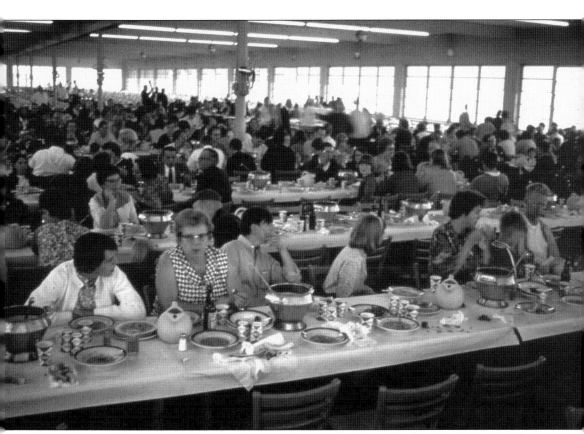

By 1993, prices for outings had increased quite a bit since the day of the 50¢ clambake. All rides for all day, including a lunch in the Shore Dinner Hall, cost $13.50 per person. Parking of course was free.

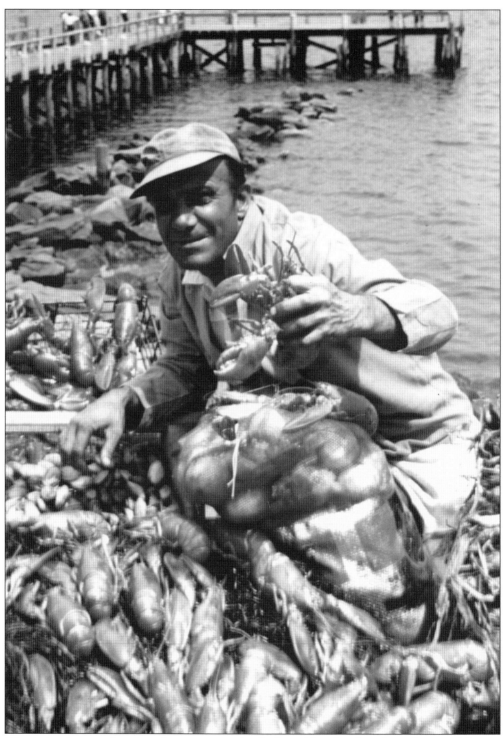

Clambake pits were dug along the water near the docks and lined with rocks and seaweed. Layers of food, including corn, onions, potatoes, lobsters, clams, mussels, and fish, would be cooked for hours using this traditional method.

This is a napkin from the first Shore Dinner Hall proclaiming Rocky Point Park as "the most beautiful spot on the Atlantic Coast from Maine to Florida." (Courtesy of Warwick Historical Society.)

The Cliff House, pictured here in the 1970s, later became offices and had a bar. It burned to the ground on October 16, 2006.

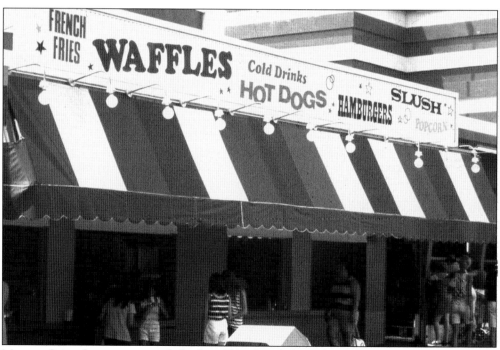

More traditional amusement park food could be found along the midway.

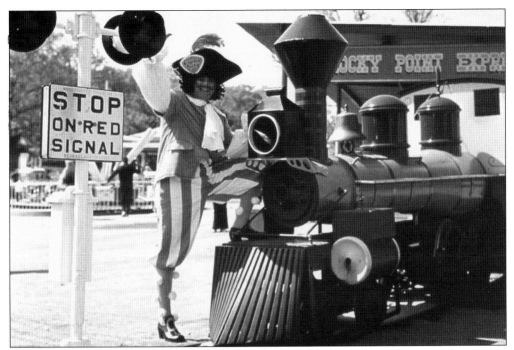
Captain Rocky was the mascot for Rocky Point Park in the 1970s. He had a pirate ship on the midway at one point and had his own club kids could join. Captain Rocky even briefly had his own television show.

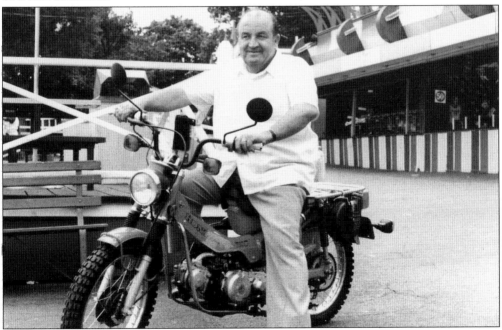
Conrad Ferla, who worked at the park for 37 years until he resigned in 1986, would always ride a motor scooter to get from building to building. Being practical and efficient, Ferla kept a total of six Honda scooters at the park. He stored one in each building, which allowed him to always travel quickly to wherever he happened to be needed. (Courtesy of Anita Ferla.)

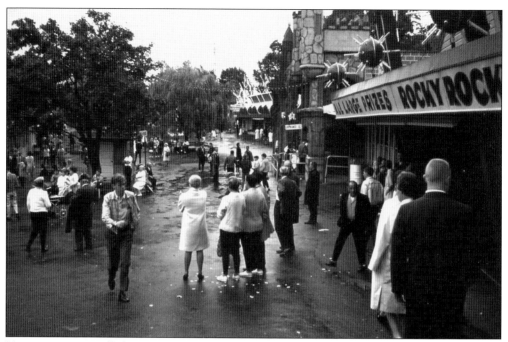
Visitors enjoy a stroll along Rocky Point's famous midway.

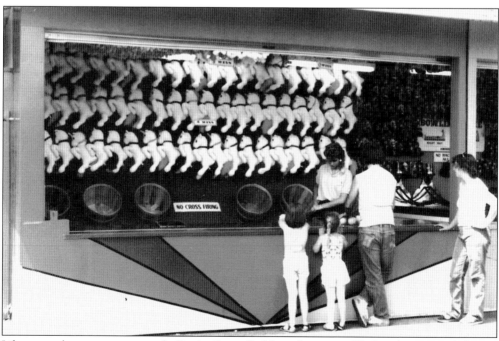
Like any other amusement park, Rocky Point Park's midway was filled with games of chance and skill. This game is a simple one; pay $1, throw the softball in the basket, and win a stuffed unicorn. Of course, there is no "cross firing."

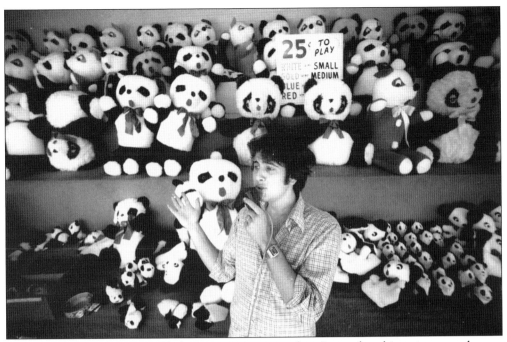

Breaking dishes with a baseball, shooting water into a clown's mouth, taking aim at a red paper star—all these things could have won someone a prize at Rocky Point Park.

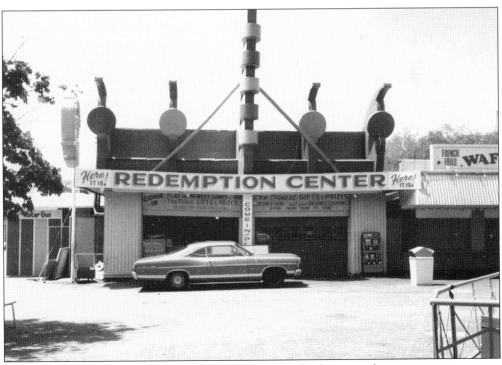

At the redemption center, one could turn in tickets won at the games for prizes.

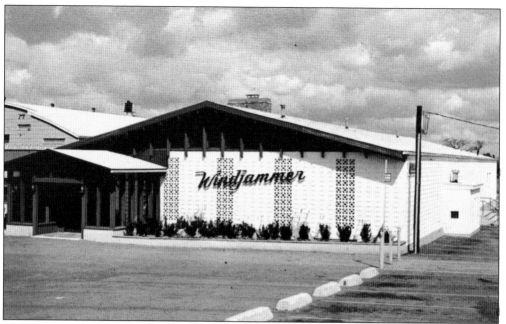

This photograph shows the Palladium and Windjammer in the mid-1970s.

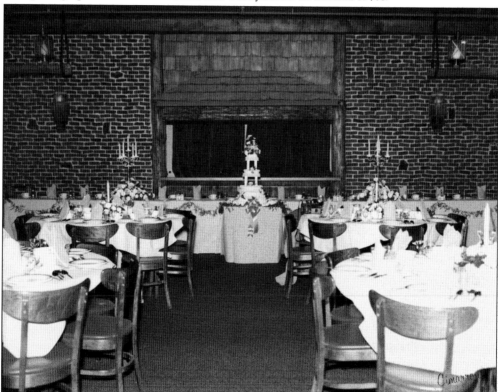

In 1974, Cheryl and John Gould, who met each other at Rocky Point Park while they were both employees, had their wedding reception in the Windjammer. At one point, in their formal attire, the newlyweds walked around the park, saying hello to their ride-operating friends.

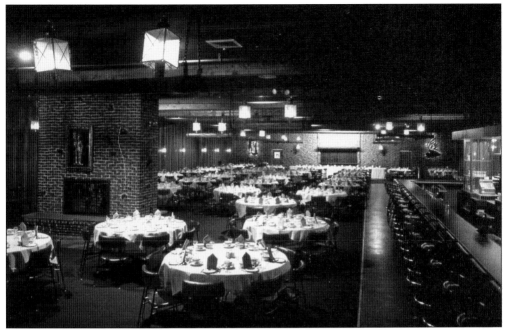

The Windjammer was built to help the park economically, allowing for functions year-round. Weddings, banquets, showers, fund-raisers, and trade shows often took place in the Windjammer.

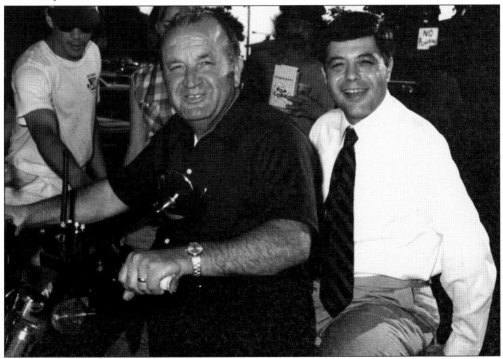

The Windjammer and Palladium often hosted political fund-raisers and post-election parties. In this photograph, Conrad Ferla rides on a scooter with Vincent "Buddy" Cianci Jr. Cianci served as the mayor of Providence from 1975 to 2002. (Courtesy of Anita Ferla.)

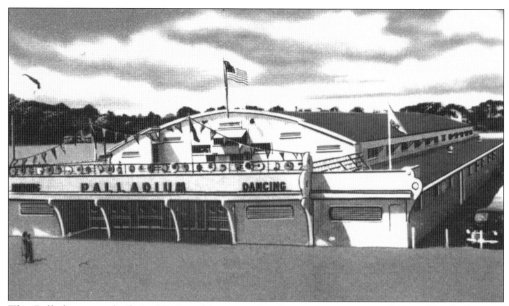

The Palladium was built in 1949 and has seen its share of concerts, including Frank Sinatra, Chubby Checker, and the Ramones.

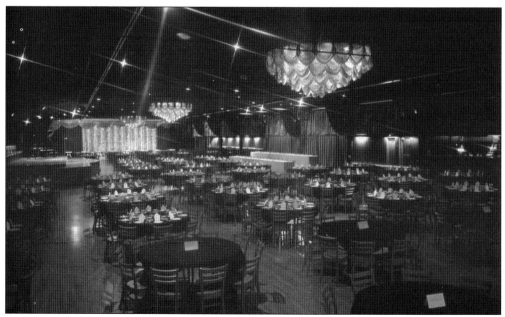

One of the more noteworthy events to take place in the Palladium was the visit of Pres. George H. W. Bush on November 20, 1989. The 41st president of the United States spoke briefly at a fund-raising reception and dinner for Republican senatorial candidate Claudine Schneider. His remarks included a joke about how the Secret Service would not allow him to ride the Corkscrew roller coaster.

Three
RIDES AND ATTRACTIONS

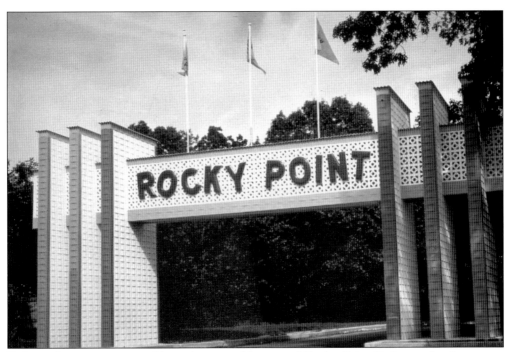

Perhaps the most recognizable and memorable part of Rocky Point Park was the front gate. Unfortunately, it was torn down on June 4, 2007. There were few onlookers on that rainy summer morning to witness the fall of this monument to Rhode Island tradition.

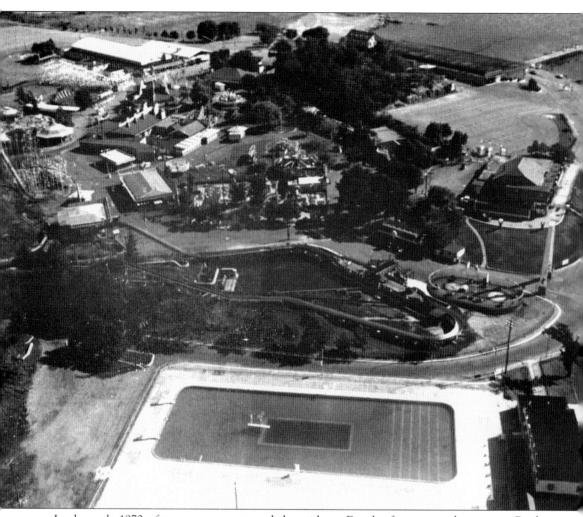

In the early 1970s, fences went up around the midway. For the first time, admission to Rocky Point Park was charged. Its cost was a mere 50¢.

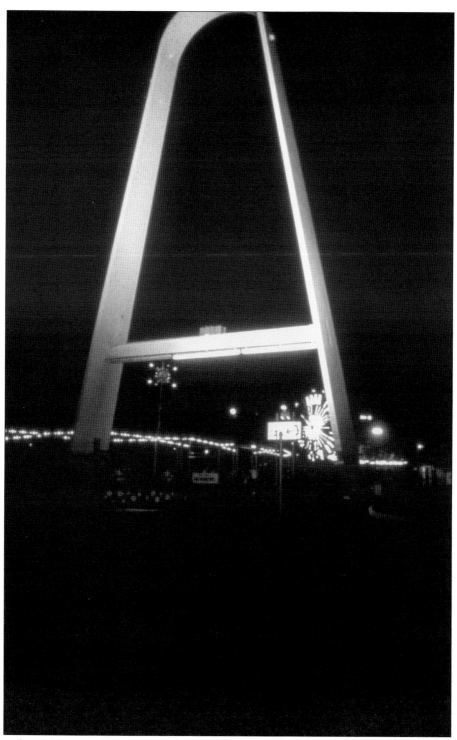
The arch, which greeted guests from the waterfront entrance, came from the 1964 world's fair in New York City. It originally had a large General Mills logo in the center and was one of three such arches displayed at the General Mills Pavilion that year.

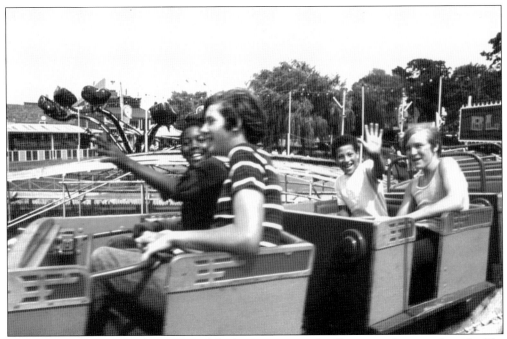

Starting around 1970, Rocky Point Park had a "pay once: ride all you want" option for rides like the Blue Streak (pictured here), the Trabant, Hell's Angel, and the Paratrooper.

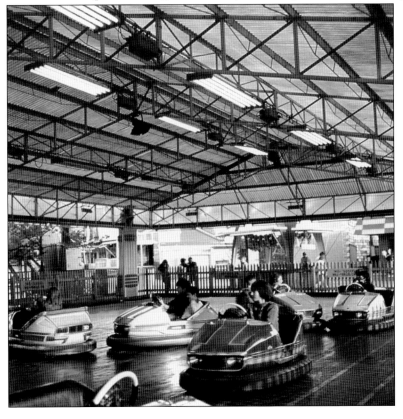

Whether they were called the Dodgems, the Skooters, or the Bumper Cars, this was one of the most popular attractions at Rocky Point Park through the years.

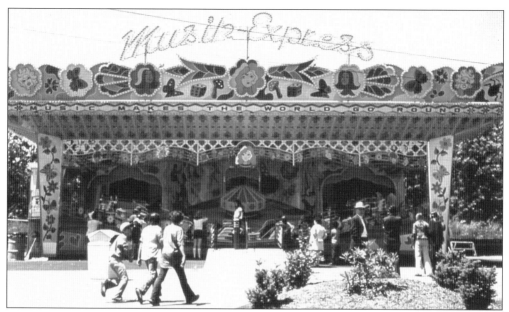

The Musik Express was manufactured by the German-based MACK Rides. It featured 20 three-passenger cars on a circular, sloped track. Notably, at Rocky Point Park, the Musik Express also moved in reverse during ride operation.

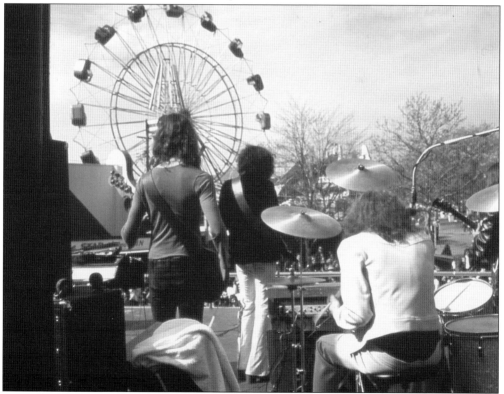

The Musik Express was not the only spot in the park to enjoy music. The stage also offered visitors a chance to be entertained by both local and national live acts.

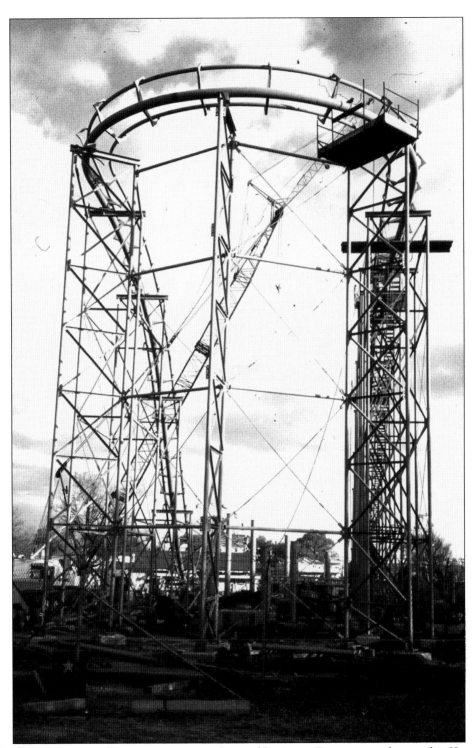

The first Corkscrew roller coaster was manufactured by Arrow Dynamics and opened at Knott's Berry Farm in 1975. Rocky Point Park purchased its coaster from Arrow Dynamics at the cost of $2 million and began construction in 1982.

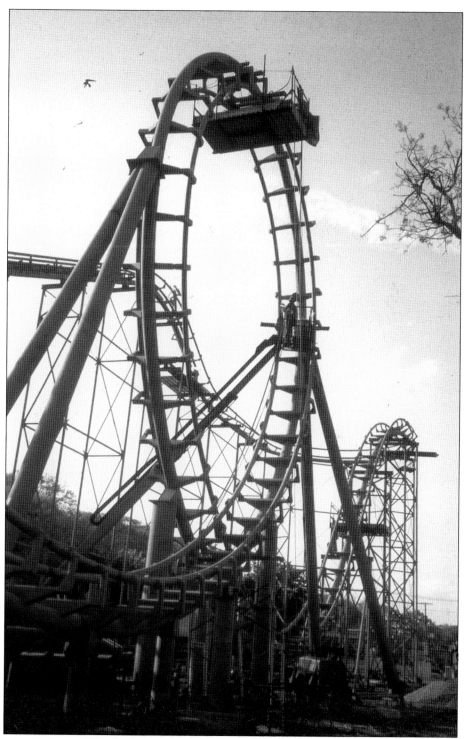

The construction of the Corkscrew was Rocky Point Park's most ambitious project. Kiddie Land and the Rocky Point Express were both affected, and many other rides and attractions were moved or relocated.

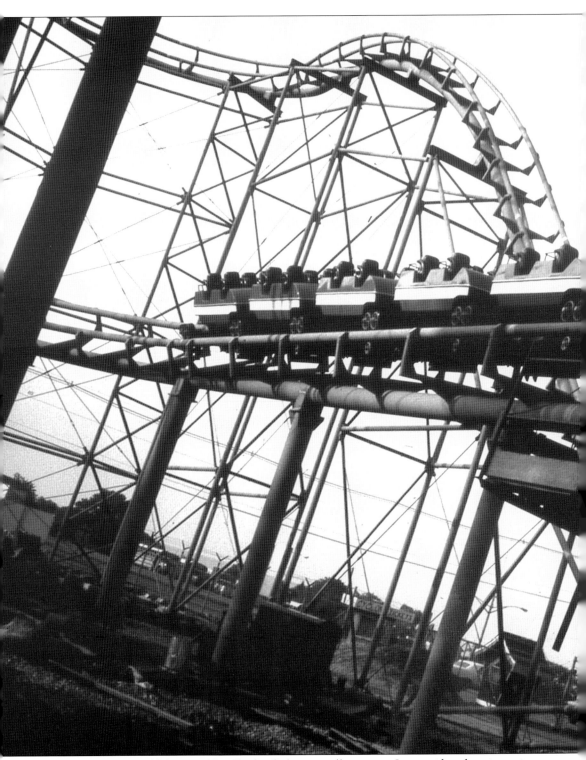
The Corkscrew quickly became New England's favorite roller coaster. It gave riders three inversions, including a full loop, during its 60-second ride. The height of the loop was approximately 60 feet

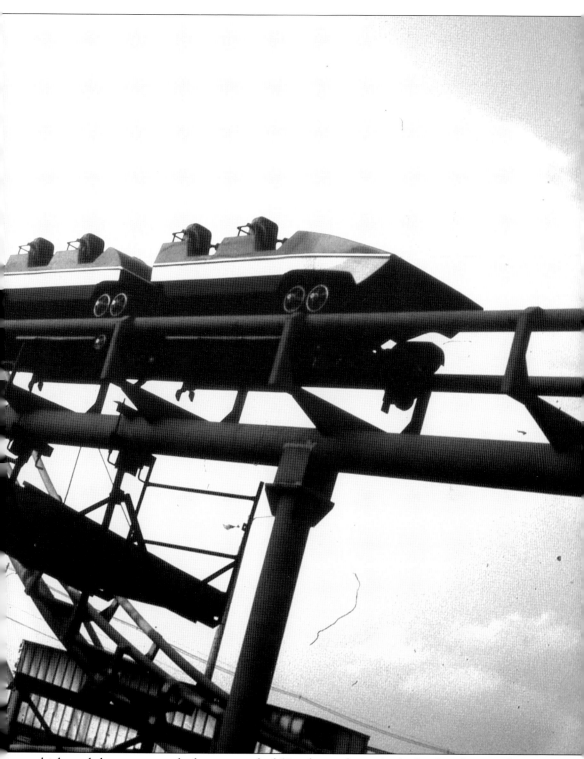
high, and the coaster reached a top speed of 50 miles per hour. At the height of its popularity, close to 1,200 guests would ride it daily.

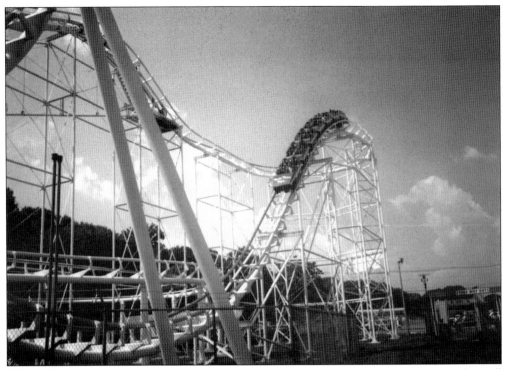
The height requirement for the Corkscrew dictated that riders had to be at least 48 inches tall to experience the thrill of this coaster.

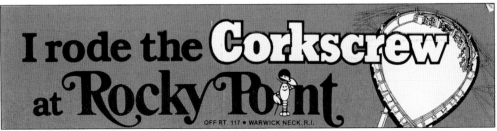
Due to its haste to build excitement over the park's new ride, Rocky Point Park management produced promotional bumper stickers and postcards prior to the coaster's installation. The images used were actually of the coaster located in Knott's Berry Farm.

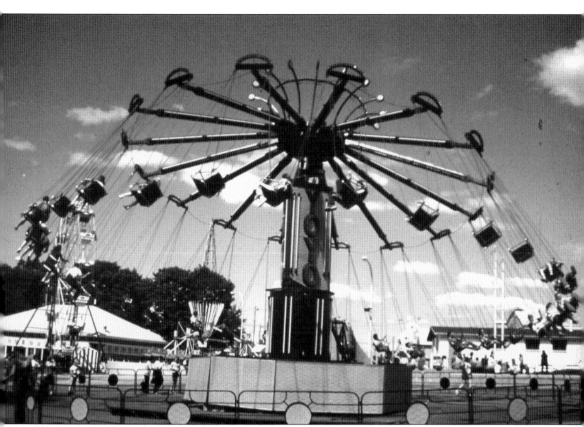
The Yo-Yo is a staple amusement park ride in parks around the country. It features hanging swings, which are arranged in a circle.

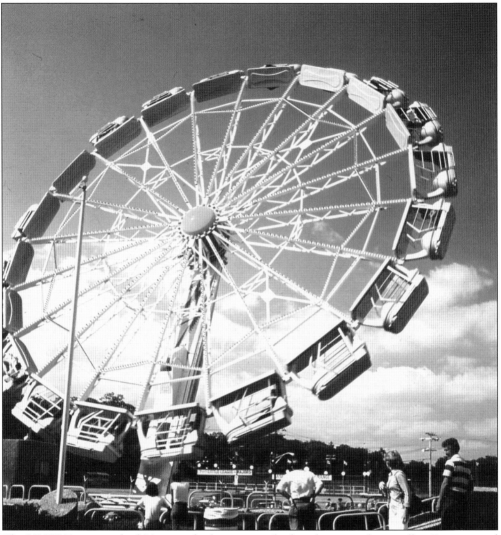

The HUSS Enterprise had 20 cars, which were attached to the center by spindles. Since it used the force generated by the motion of the ride to keep passengers in their seats, it was one of the few amusement park rides that required no safety restraints.

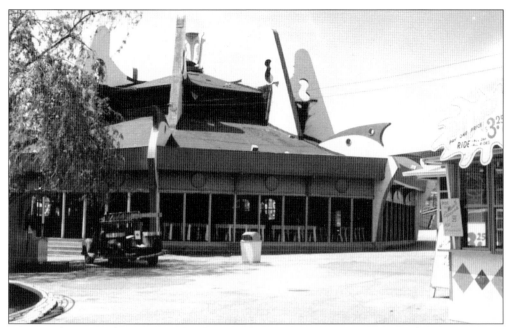

In December 1974, the structure that held the large carousel was reconstructed to create a more open design. Rocky Points's master carpenter Jack Gould was responsible for this as well as the construction of many midway buildings and rides throughout the 1970s.

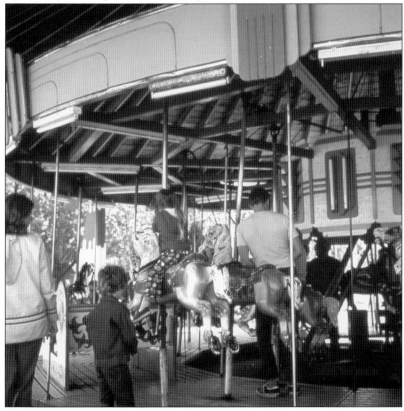

The Kiddie Carousel, shown here, was one of two carousels in the park.

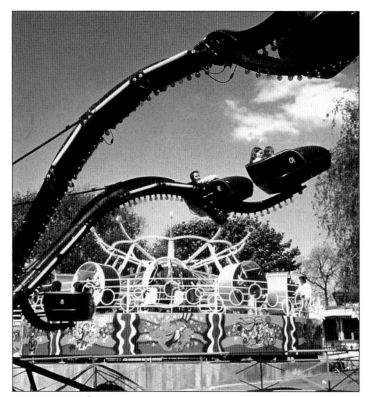

The Rok-n-Rol, pictured here behind the Spider, was manufactured by the Chance Manufacturing Company. The ride featured eight circular tubs that tumbled and flipped riders.

The Eyerly Aircraft Company's Spider had eight arms, each of which supported two cars. As the arms rotated around the ride in an up-and-down motion, each car spun in tight circles.

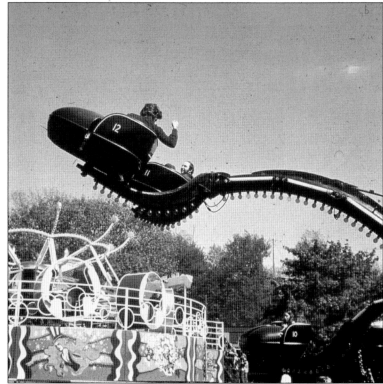

76

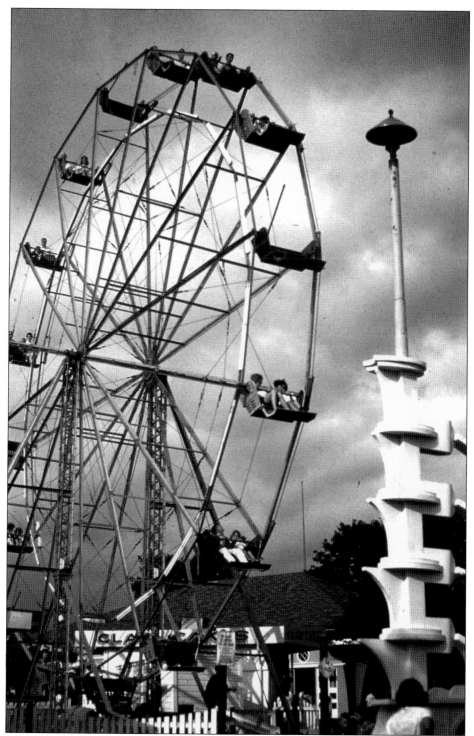
The Ferris wheel is a classic ride that has been found in amusement parks across America for well over a century. The Ferris wheel, which towered over Rocky Point Park, afforded a magnificent view of the Narragansett Bay.

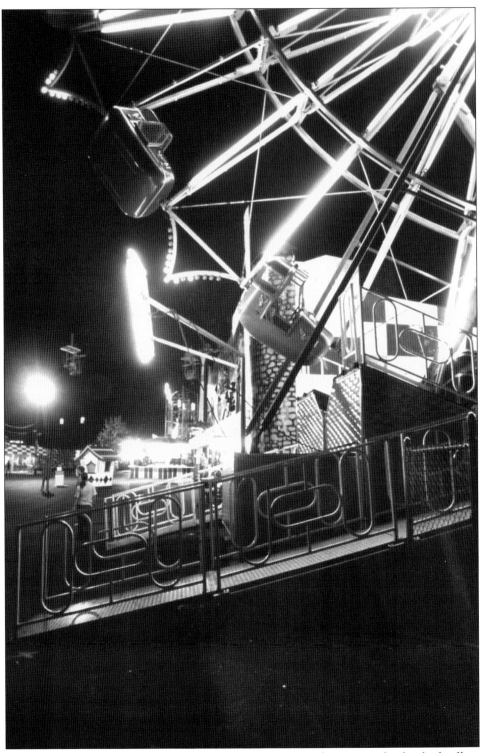

Similar to the Ferris wheel, the Skydiver had a rider-operated steering wheel, which allowed people to spin their car while the ride was turning.

Pictured here by the Wildcat is ride operator Frank Cook in 1971. Next to him is the "kick-off" brake, which the operator would pull to enable the car to go out on to the track. (Courtesy of John and Cheryl Gould.)

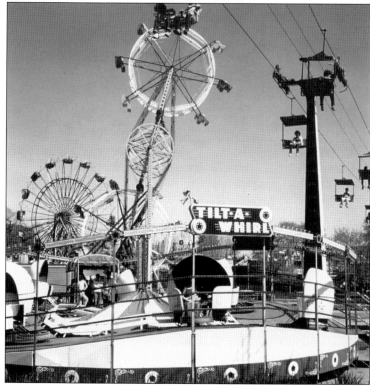

Another classic ride, the Tilt-a-Whirl consisted of seven cars that spun in concentric circles on a platform. The Skydiver and the Skyliner can also be seen in this picture.

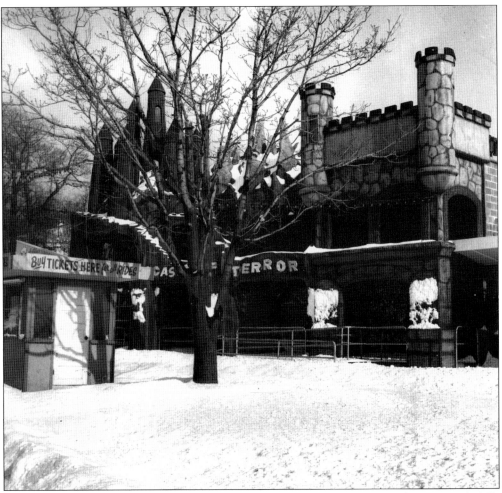
The Castle of Terror was the park's classic dark ride. When it debuted in the spring of 1963, female park employees, dressed as nurses, stood at the exit of the ride. The intention, of course, was to imply that the ride was so terrifying that riders would require medical attention. (Courtesy of George LaCross.)

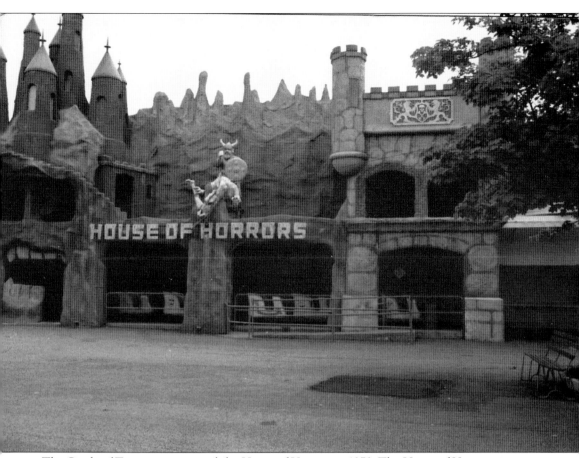

The Castle of Terror was renamed the House of Horrors in 1970. The House of Horrors sign was moved to the Castle of Terror from another dark ride in the park that had operated from 1948 to 1962. Some of the stunts inside the ride included Torture Chamber, Old Mill, and the Viking. (Courtesy of George LaCross.)

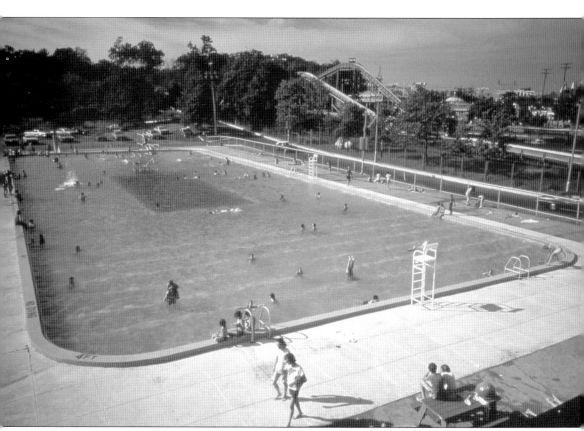
The saltwater pool at Rocky Point Park was a separate admission, had lifeguards on duty, and was 12 feet in its deepest spot.

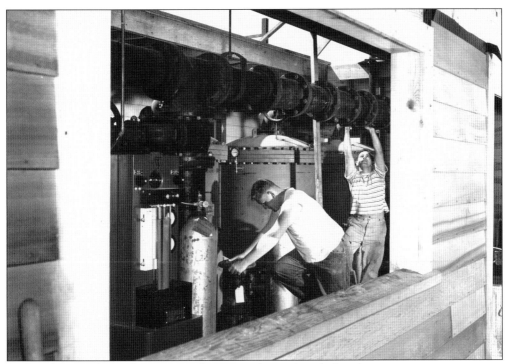
In this photograph, Rocky Point employees get the pool ready for a busy summer.

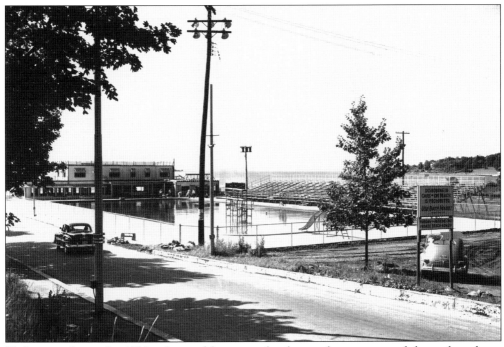
Unfortunately, in the 1980s, the pool became a burden to the economy of the park and was becoming more and more costly to operate and maintain. It was closed and filled in.

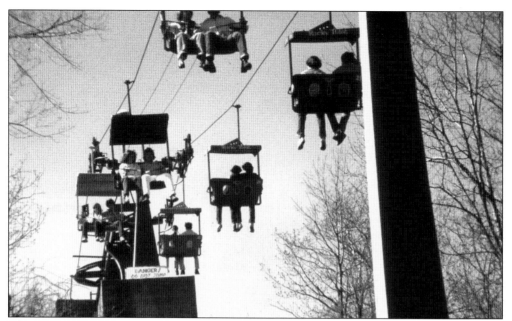
The Skyliner was a simple ride: ski lift chairs slowly made their way from one side of the park to the other, allowing a bird's-eye view of Rocky Point.

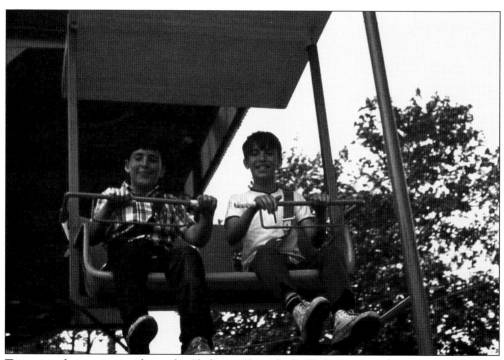
Two young boys enjoy a ride on the Skyliner. The ride thrilled visitors with an amazing view of Narragansett Bay. (Courtesy of Anita Ferla.)

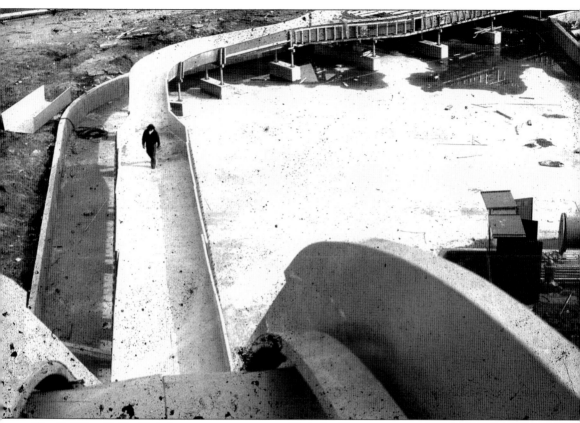
The "Million Dollar Ride," as it was sometimes called, the Flume was one of Rocky Point Park's most ambitious construction projects of the 1970s.

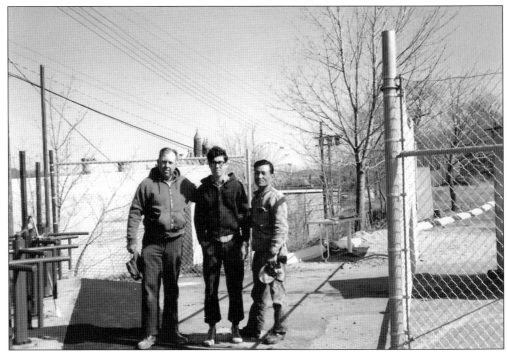

Jack and John Gould stand with a Japanese engineer in charge of the Flume's construction. At the time, admission to the park was 50¢. One could buy a "pay one price" bracelet and ride all the rides all day for $3. (Courtesy of John and Cheryl Gould.)

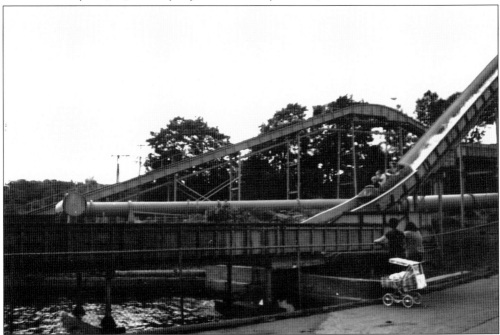

Finding a place for the Flume proved to be a challenge, as numerous attractions had to be rerouted and moved to accommodate the long, winding ride. It was 45 feet high at its highest point and had about a half mile of track.

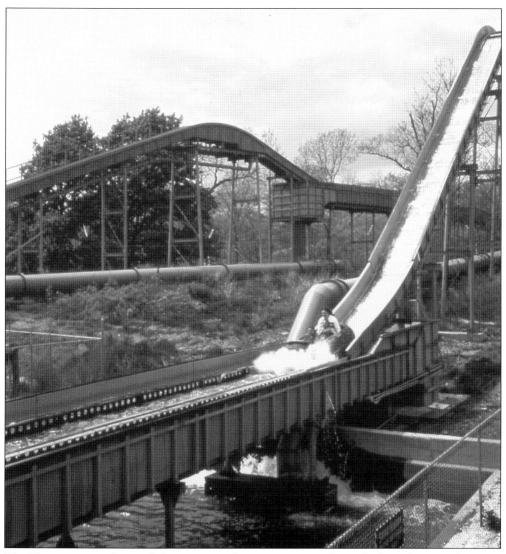

The Flume remained one of the most popular attractions at the park throughout Rocky Point Park's history. It was sold at the auction in 1996 and was moved to the Enchanted Kingdom in the Philippines, where it is now called the Jungle Log Jam.

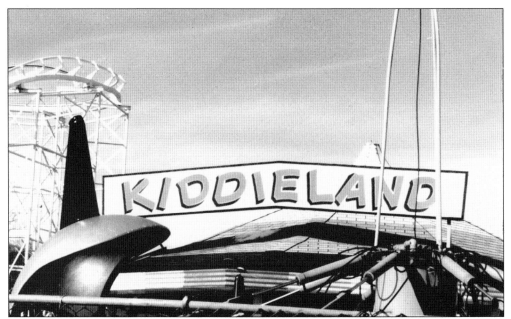

Frank Chapman was a commercial artist who was often contracted to do a great deal of work for the management at Rocky Point Park. Later in life, he took up photography and enjoyed taking pictures of the different rides. This is his photograph of the entrance to Kiddie Land. (Courtesy of Barbara Chapman.)

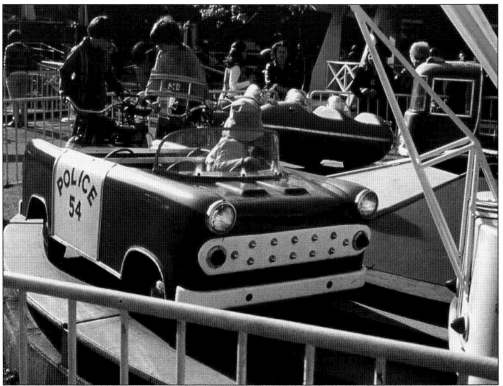

On the Antique Cars, kids take a slow ride along a tree-lined track.

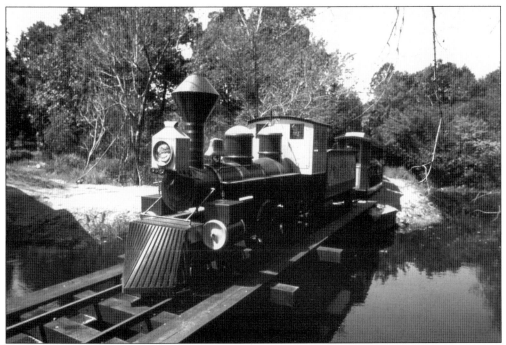

The Rocky Point Express ran through a wooded area that was located under the rear track of the Flume. Passengers knew that a trip on the train always included being playfully splashed by riders who floated along the track above them on the flume logs.

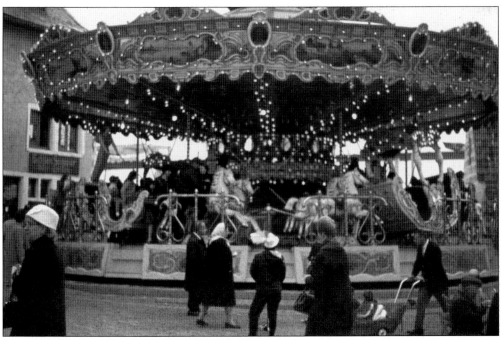

The smaller carousel at Rocky Point Park had beautiful panels of interesting scenes to gaze at while riding on the backs of these diminutive merry-go-round horses.

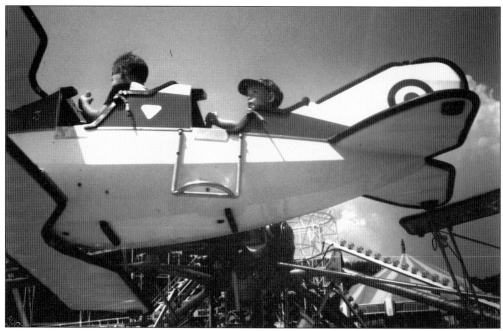

For children too small for the adult rides, Kiddie Land was the perfect substitute. These planes moved in a circle and up and down, and while simple, provided hours of fun for the little ones.

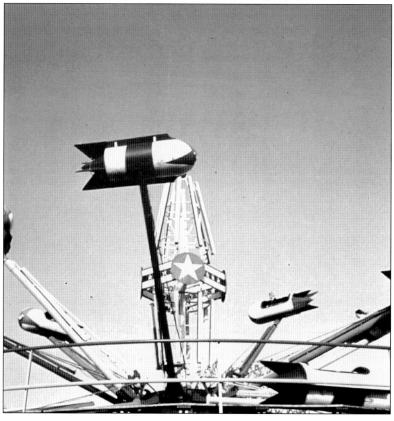

In the Roto Jets, one became the pilot, steering a jet up and down while spinning around in a circle.

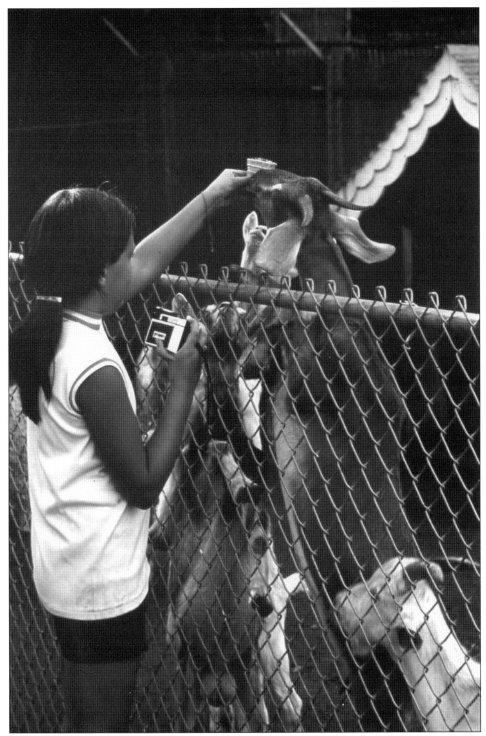
For a number of years, Rocky Point Park had a petting zoo, where children could touch and get close to many different domestic animals, from pigs and goats to more exotic animals, like emus and llamas.

At a classic ride at Rocky Point Park, generations of children would choose their favorite motorcycle to take for a spin on a circular track.

This photograph shows good clean fun on the Whirlybirds, a ride for kids in Kiddie Land.

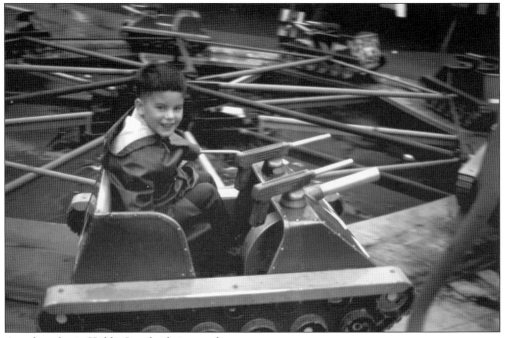
Another classic Kiddie Land ride is seen here.

Alvin H. Cohen of New York City purchased Rocky Point Park in 1969 for $1.2 million.

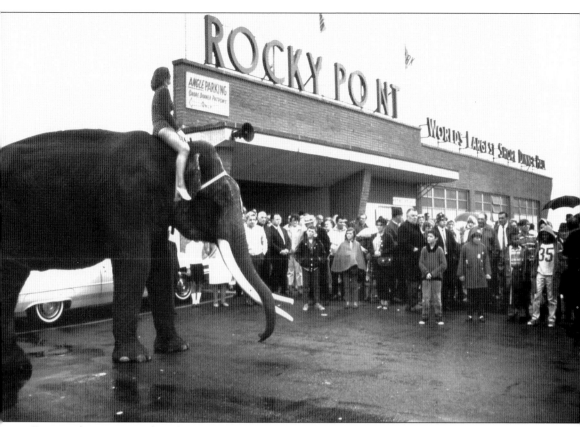

Despite the rain, crowds gather outside the Shore Dinner Hall to see one of the circus acts. This trained elephant performed tricks on the midway for delighted crowds.

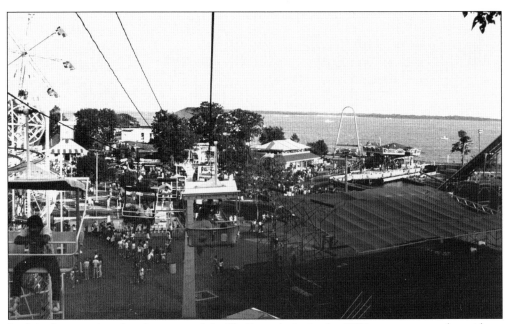

In this photograph, taken from one of the Skyliner chairs in the 1980s, one can see the midway stage, where many bands, singers, and dancers performed.

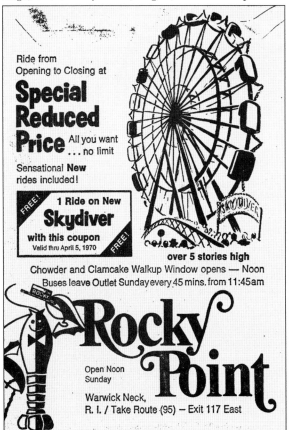

In this advertisement for the park, around 1970, the Skydiver is advertised as one of the new and exciting rides at Rocky Point Park that season.

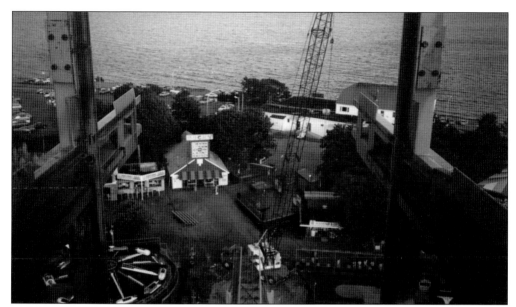

In 1984, a ride called the Edge had a serious accident that injured four teenagers. Despite being fitted with new safety features, its ridership remained low, so it was sold and relocated to Rocky Point Park in 1988. At Rocky Point Park, it was known simply as the Free Fall.

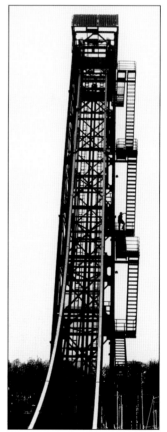

One needed to be 42 inches or taller to ride the Free Fall, which was an Intamin first-generation free fall ride that fell 13 stories and reached a speed of approximately 55 miles per hour.

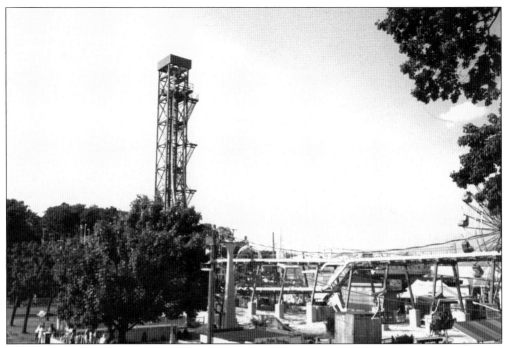

The Free Fall would be the last new ride Rocky Point Park would add to its midway.

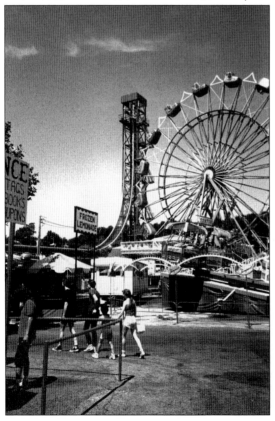

In 1996, it was sold at auction and relocated to Geauga Lake in Ohio where it was renamed Mr. Hyde's Nasty Fall. It was dismantled for good in 2006.

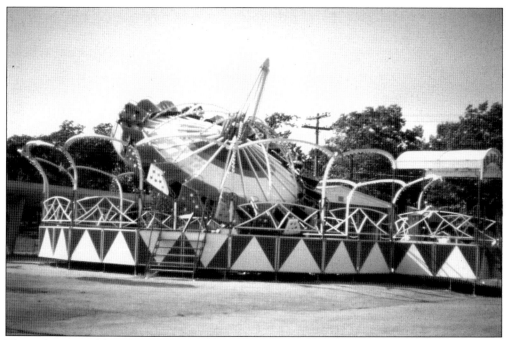
This ride, created by Chance Manufacturing Corporation, has a ring of cars that dip and dive and climb as they spin around.

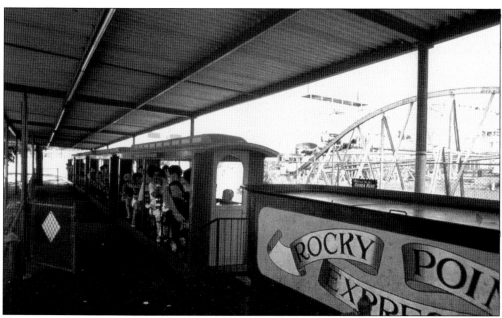
The train that was at the park when it closed was purchased around 1978. It was manufactured by Chance Manufacturing Corporation in Wichita.

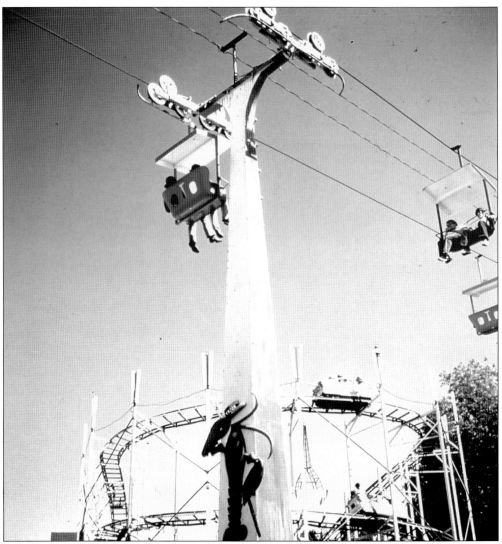
Rocky the Lobster was Rocky Point Park's mascot and icon for many years. Large fiberglass lobsters would adorn various buildings throughout the park.

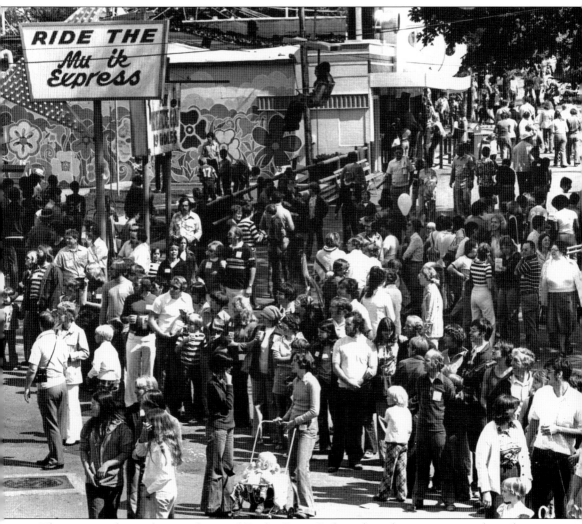

This picture shows the popularity of Rocky Point Park each and every summer throughout the 1970s.

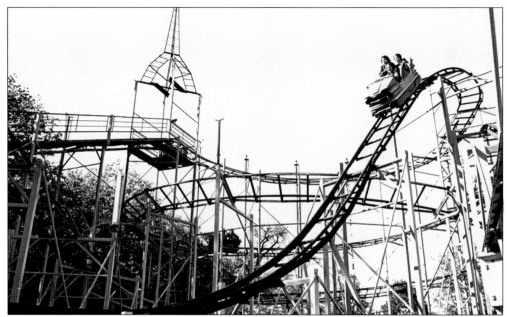

Rocky Point Park had six major roller coasters in its history, which were the Comet Junior, the Cyclone, the Flying Turns, the Corkscrew, the Up 'n' Atom, and the Wildcat.

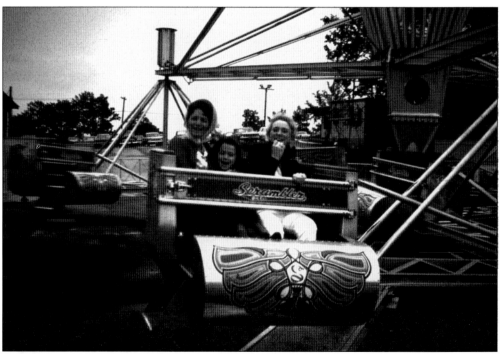

Eli Bridge created its first Scrambler in 1955, and it has been a staple at amusement parks ever since. Rocky Point Park was no exception. Its Scrambler was one of the park's most beloved rides.

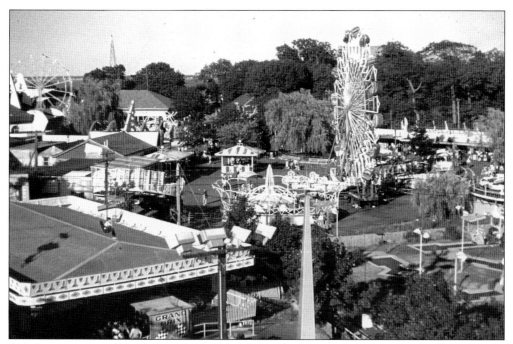

This is a great shot of the midway in the late 1970s. The miniature golf course, the Skydiver, and the Grand Prix Bumper Cars can all be seen.

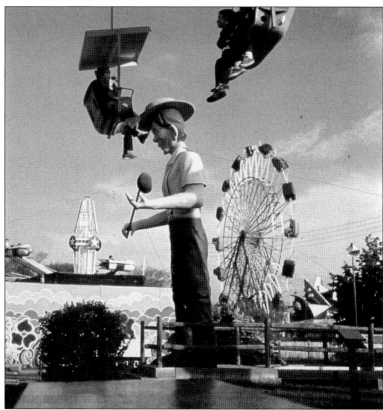

This tall statue stood guard over the miniature golf course.

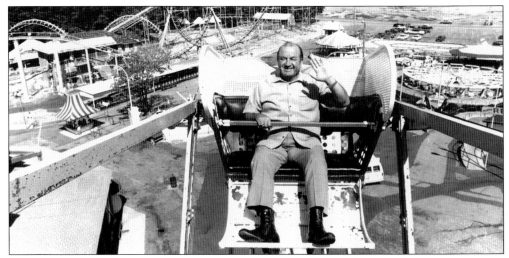
Conrad Ferla, who worked at the park from 1949 to 1986, takes a ride on the Ferris wheel in 1984.

As the 1990s rolled in, Rocky Point Park was finding it harder and harder to compete with the major theme parks. It was becoming more expensive to operate the park, and few physical improvements were made. The Free Fall was the last major ride to be installed.

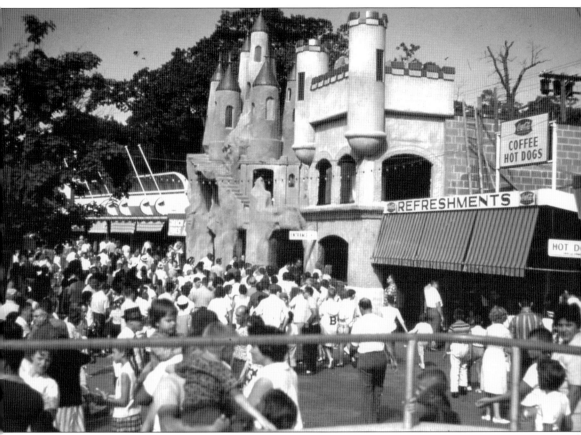

From 1963 to 1970, another dark ride had its home at Rocky Point Park along the midway. Jungle Land took riders in beige jeeps on an adventure through the dark continent, narrowly escaping giant snakes, charging rhinos, and angry, tusked elephants. It was renamed Jungle Terrors just before it was razed to make way for the Sky Diver.

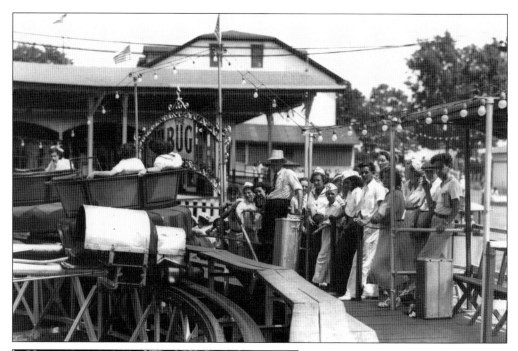

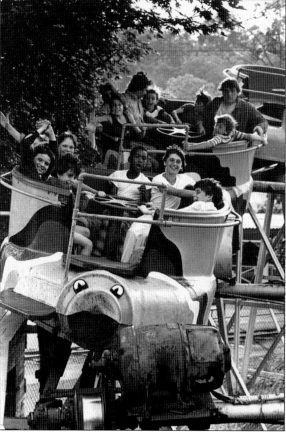

The Tumble Bug was one of Rocky Point Park's early rides, a favorite of both children and adults. Created by the Traver Engineering Company of Pennsylvania, it got its name due to its insectlike movements. The ride featured six cars that would spin and roll on a circular wooden track. (Courtesy of John Caruthers.)

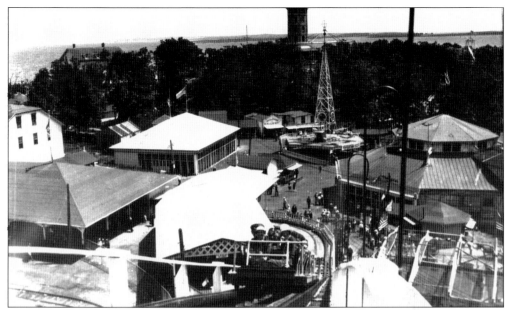

Designed by the great roller coaster designer Herbert Schmeck, the Wildcat, built at Rocky Point in 1926, had a lift hill similar to modern-day roller coasters.

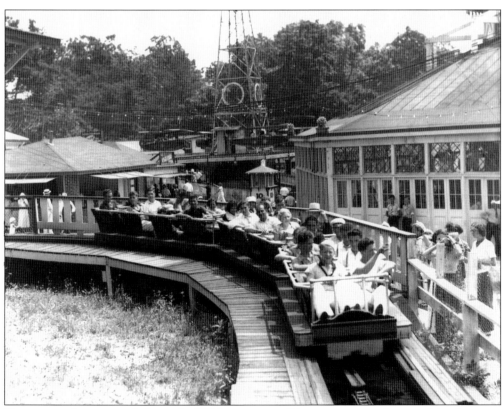

Here is another view of the early Wildcat coaster. The coaster was destroyed in the great hurricane of 1938.

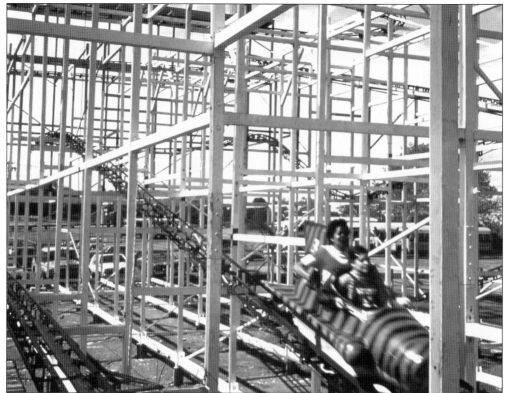

This is a photograph of Jack Gould and his son John on the Wildcat. While they shared the same name, this Wildcat coaster was quite different than its wooden predecessor. Walter Bailey, a former Wildcat ride operator, remembers the manual brakes used to slow and stop the cars. (Courtesy of John and Cheryl Gould.)

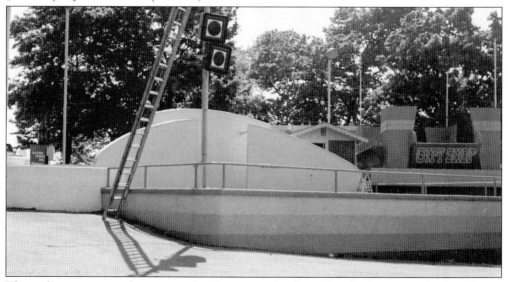

The midway stage was always a popular place to see local acts, bands, dancers, and talent shows. It also hosted acts of national notoriety. The likes of the Three Stooges, Leonard Nimoy, and the Teenage Mutant Ninja Turtles have all taken to the Rocky Point Midway Stage.

In November 1980, a mysterious fire caused extensive damage to the buildings on the midway. A few years later, it proved to be arson. A subsequent trial ended in a maintenance worker being convicted of setting the blaze.

Starting in the 1960s, the Warwick police kept a few officers on duty at the park to handle security issues and help alleviate traffic problems. This building, tucked away behind the midway, acted as a jail for rowdy patrons. The first jail installed at the park was done so at the request of Byron Sprague. His intention was to create a temporary holding area for inebriated guests.

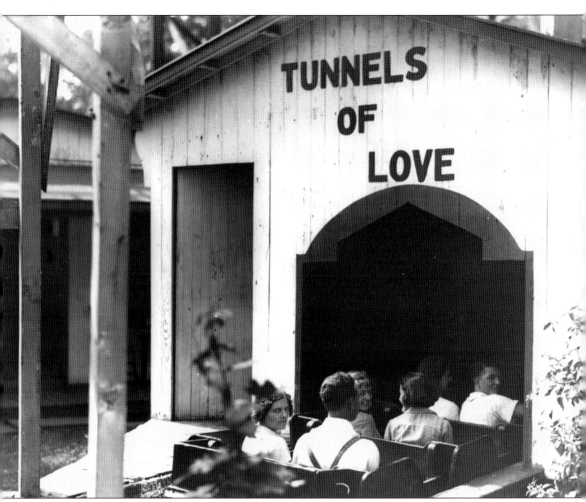
Here is yet another dark ride at Rocky Point, but this time it was for lovers. A slow, romantic ride through the Tunnels of Love got one in the mood in the late 1930s. (Courtesy of John Caruthers, photograph by Paul Haney.)

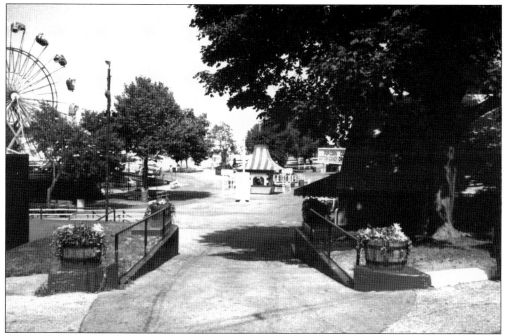
This is the view of the park as one walked from the Cliff House down into the midway.

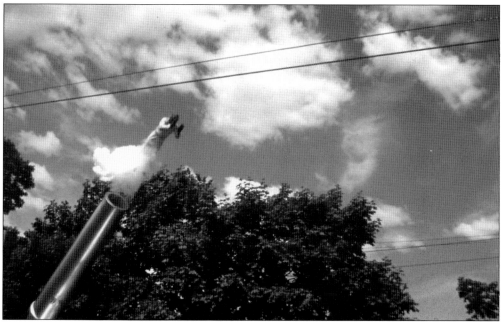
Hugo Zacchini, the great human projectile, would perform his amazing daredevil stunts on the midway. (Courtesy of Al Albino.)

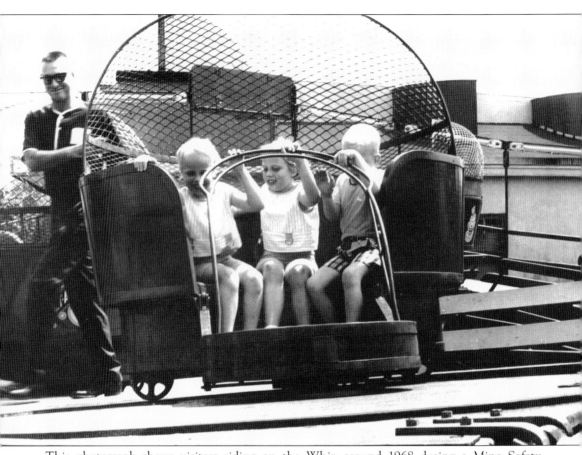

This photograph shows visitors riding on the Whip around 1968 during a Mine Safety Appliance Company outing. From left to right are Patty, Dottie, and Walter Sullivan. (Courtesy of Walter Sullivan.)

Four
Ruins and Demolition

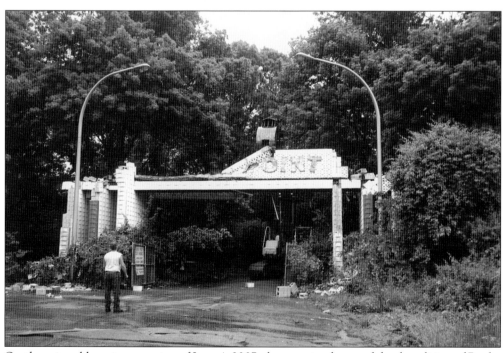

On the miserable, rainy morning of June 4, 2007, the crew in charge of the demolition of Rocky Point Park took down the front gate. (Photograph by Nicole Gesmondi.)

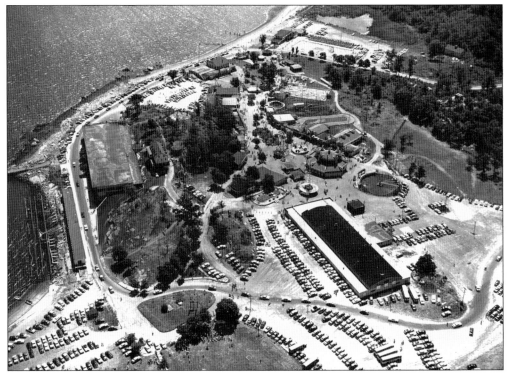

By 1994, poor business decisions and stiff competition from major theme parks had put the owners of Rocky Point Park deep in debt. In its last summer season, 1995, the park grossed less than $20,000. It began to be more and more evident that the numerous concessions that had been made by lenders and town tax collectors would still not be enough to keep the park in operation. Eventually management's appeals for more time were denied. Time was running out.

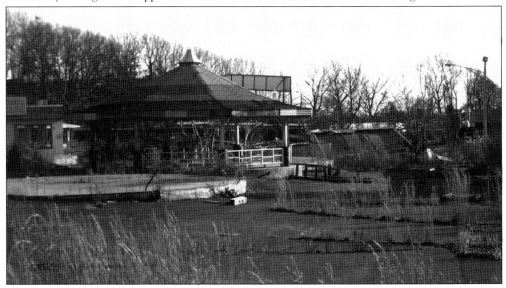

In April 1996, Norton Auctioneers of Michigan held an auction for all of Rocky Point Park's rides and equipment. Despite fierce wind and rain, people from all over New England come by to try to get a piece of their beloved Rocky Point Park.

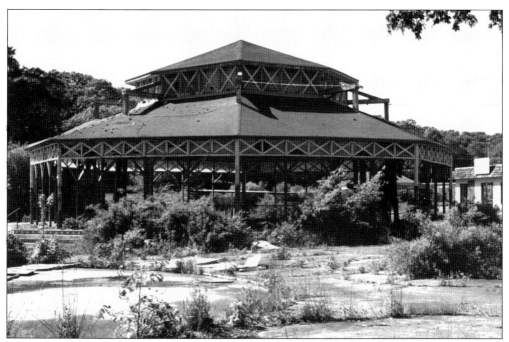
In the years following the auction, Rocky Point Park fell into disrepair. In this photograph, the carousel building stands amid the overgrown midway. Two years later, it would collapse. (Photograph by Nicole Gesmondi.)

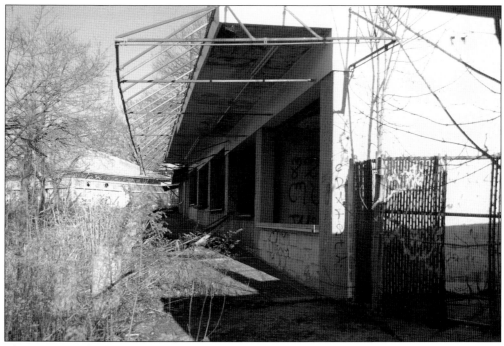
The game stands along the midway are now empty and covered with graffiti. (Photograph by Nicole Gesmondi.)

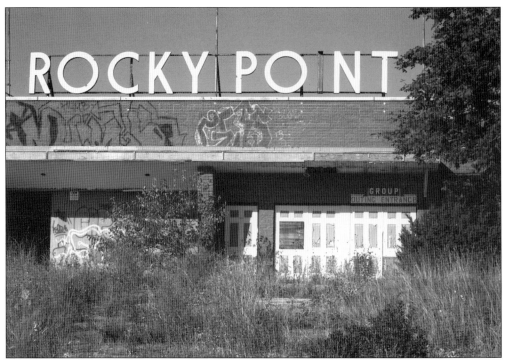

Here is the Shore Dinner Hall, as it stood in 2007. The large letters that adorned the building for many years were taken down by workers from the Trinity Repertory Company for use in the set design of their play *The Fantasticks*. (Photograph by Nicole Gesmondi.)

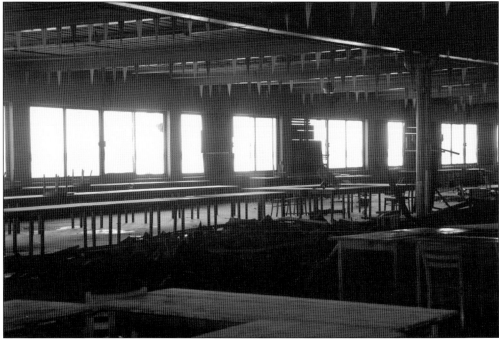

Once a majestic dining hall, the world's largest Shore Dinner Hall is pictured here in ruin with a leaky roof and a floor littered with piles of debris. (Photograph by Nicole Gesmondi.)

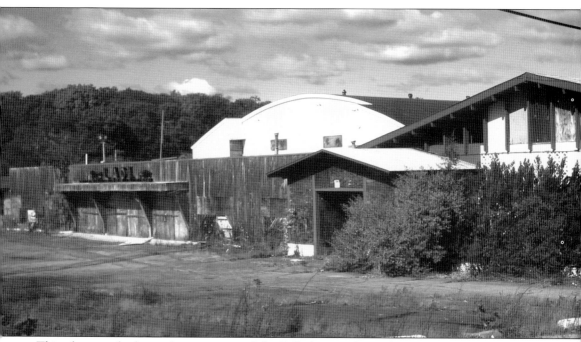

This photograph shows the remnants of the Palladium and Windjammer. Demolition crews did not take down these buildings in May 2007, leaving any future property owners to decide their fate.

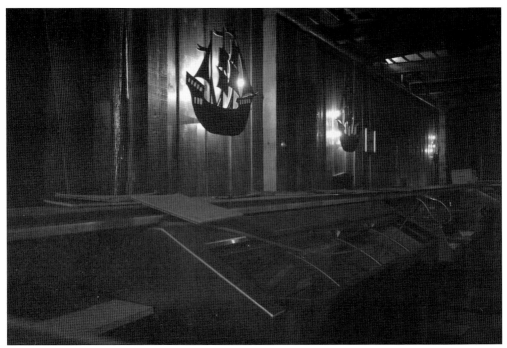
The lights are on in the Windjammer, but no one is home. (Photograph by Nicole Gesmondi.)

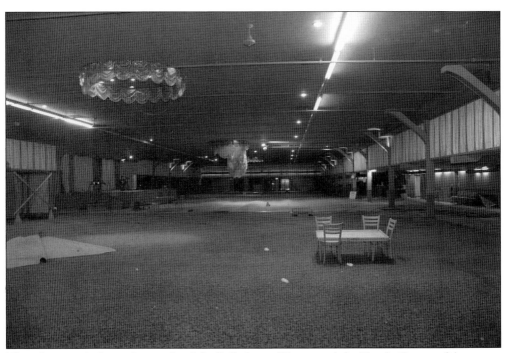
This photograph shows the inside of the Palladium. (Photograph by Nicole Gesmondi.)

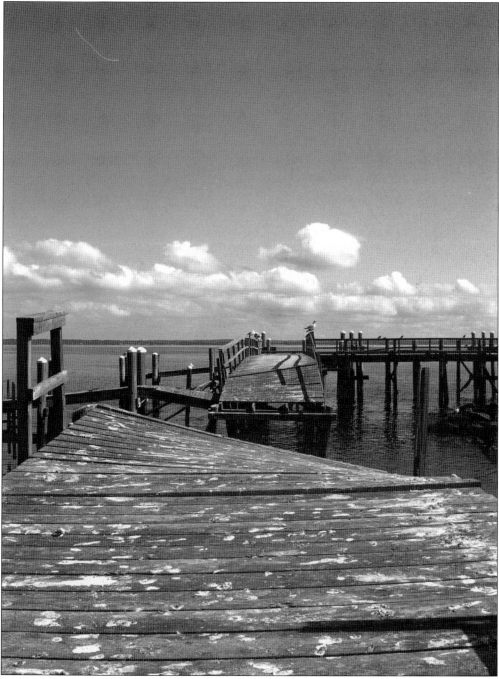
For decades, steamships and leisure boats would pull up to this dock to drop off passengers at Rocky Point Park. Now it sits in ruin, pieces slowly falling off and into the bay. (Photograph by Nicole Gesmondi.)

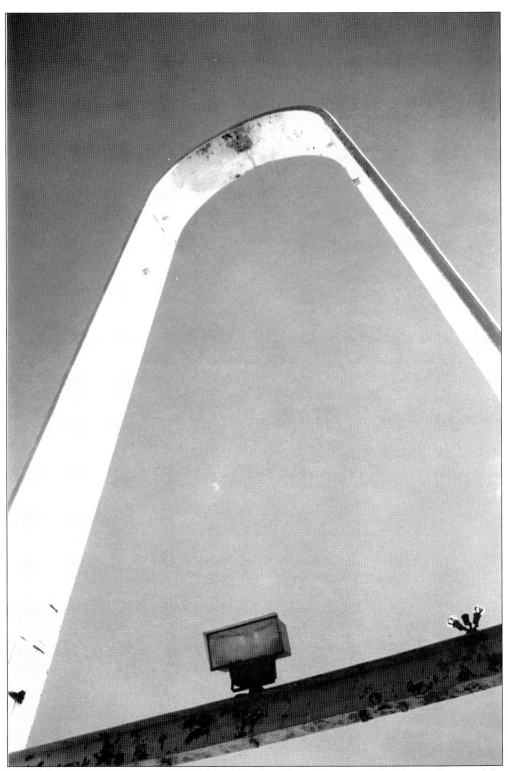
The arch still stands as a reminder of the park's glory days. (Photograph by Nicole Gesmondi.)

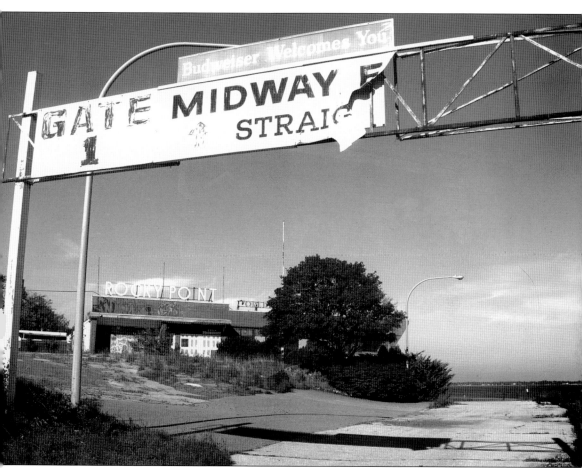
Shown here are gate 1 and the main entrance to the park, which was along the water. The Shore Dinner Hall sits in the background. (Photograph by Nicole Gesmondi.)

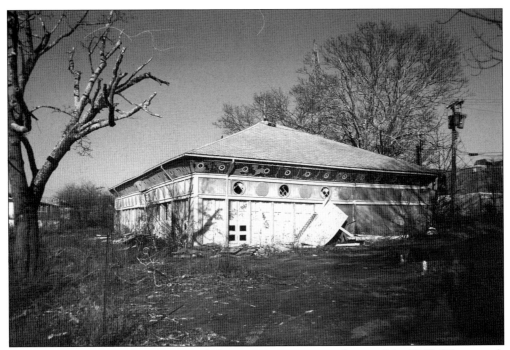

This building, home to the penny arcade for many years, was torn down in May 2007. (Photograph by Nicole Gesmondi.)

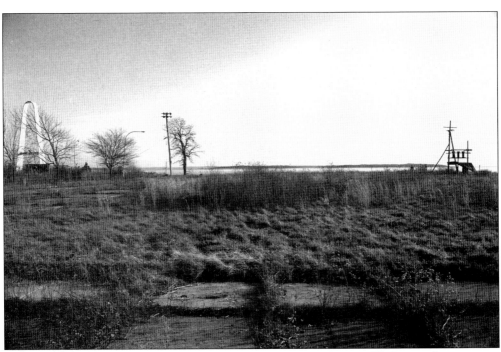

In this photograph one can still see the outline of the pool, now filled in and overgrown. (Photograph by Nicole Gesmondi.)

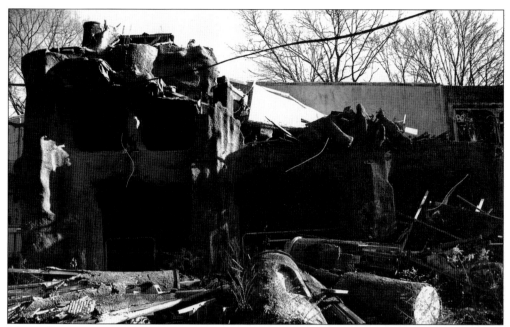

This is the House of Horrors as it stood just before its demolition in May 2007. The ride was sold at the auction for $1,500 but was never completely removed. (Photograph by Nicole Gesmondi.)

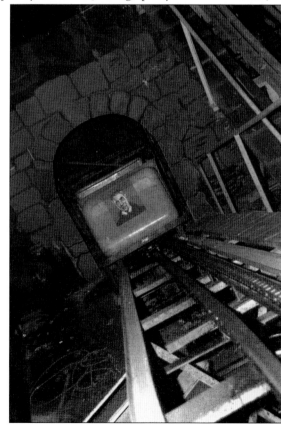

One of the House of Horrors cars is photographed here, still on the track. While filming for the documentary *You Must Be This Tall: The Story of Rocky Point Park*, the film crew counted seven cars still inside. By the time demolition crews rolled up to knock it down, there were only two left. Where have they gone? (Photograph by Nicole Gesmondi.)

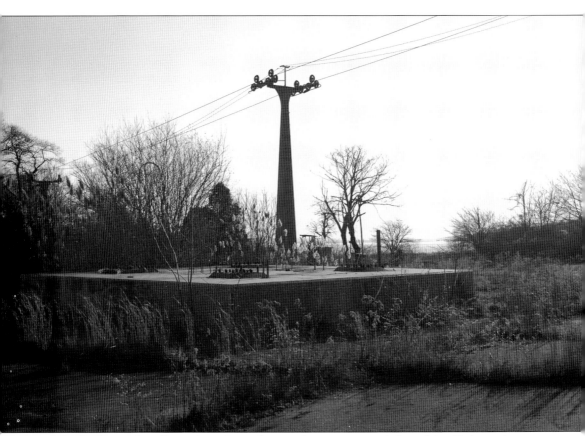

The Skyliner ride still sits along the midway with wires intact. A few of the Skyliner chairs are piled along the midway. (Photograph by Nicole Gesmondi.)

The Corkscrew was sold at the auction and moved out west to Wild Waves Enchanted Forest, a park outside Seattle, where it operates today. (Photograph by David Bettencourt.)

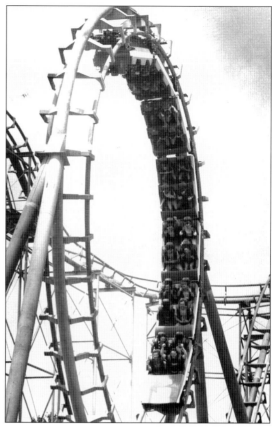

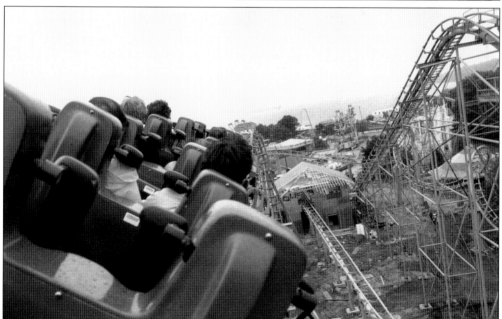

Now called the Wild Thing, the loop corkscrew coaster is still exactly the same as it was at Rocky Point Park with one exception: it got a new paint job. (Photograph by David Bettencourt.)

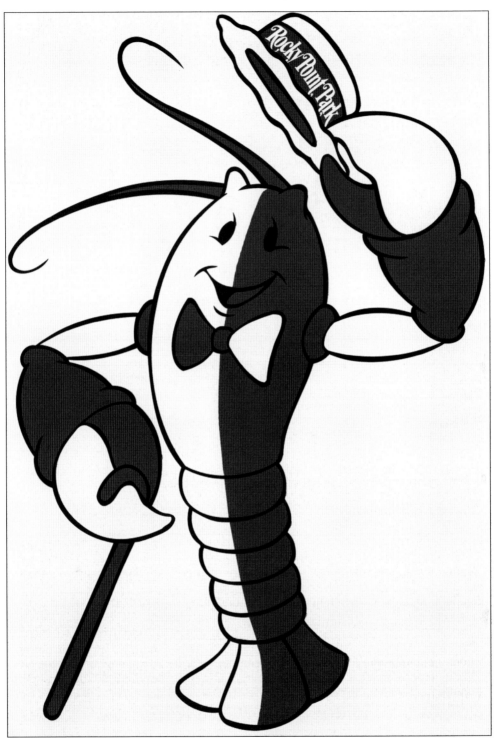
Rocky Point Park was an inspiration to Lon Smart and helped guide him to his current career as an art director and designer for Walt Disney World. He worked for 10 years as a Disney animator and drew this rendition of Rocky the Lobster.

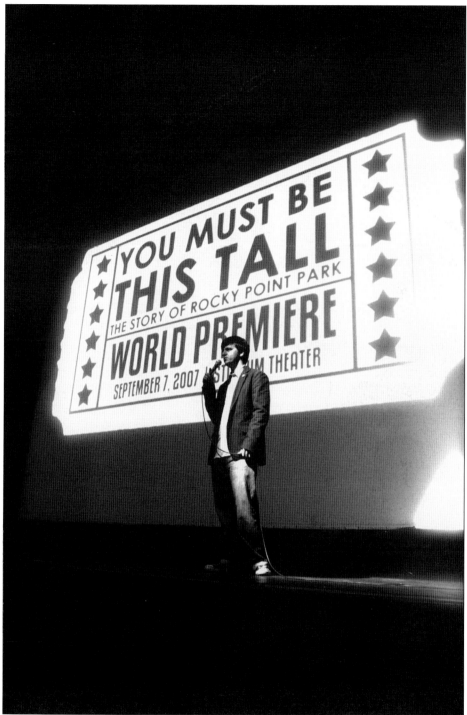

On September 7, 2007, a feature-length documentary titled *You Must Be This Tall: The Story of Rocky Point Park* made its premiere at the Stadium Theatre in Woonsocket. The film was a surprise hit, spending six weeks in local cinemas as people from throughout New England watched and reminisced about their beloved amusement park.

Across America, People are Discovering Something Wonderful. Their Heritage.

Arcadia Publishing is the leading local history publisher in the United States. With more than 3,000 titles in print and hundreds of new titles released every year, Arcadia has extensive specialized experience chronicling the history of communities and celebrating America's hidden stories, bringing to life the people, places, and events from the past. To discover the history of other communities across the nation, please visit:

www.arcadiapublishing.com

Customized search tools allow you to find regional history books about the town where you grew up, the cities where your friends and family live, the town where your parents met, or even that retirement spot you've been dreaming about.